BLACK AMERICA SERIES

# SEMINOLE COUNTY

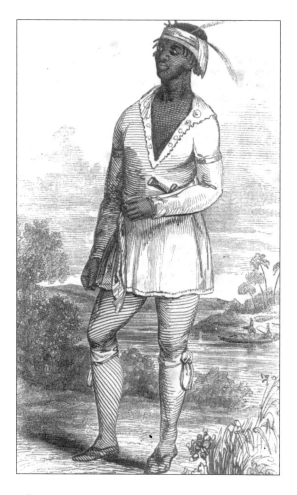

John Gopher, shown here, represents some of the early African Americans to live in Seminole County. He was one of many black Seminoles who worked as guides and interpreters. Africans have a more than 400-year history in Florida, beginning with the Spanish exploration of the coast and the St. Johns River. The first Africans to reach Seminole County could have been among the early Spanish explorers of the St. Johns River and certainly were among the escaping plantation slaves of the British colonial years and the later American expansion in the Southeast. The remote regions of Seminole County were sanctuaries for many Africans, the allies of the Seminoles during more than four decades of wars and hostilities during the early to mid-1800s. Along the sparsely populated regions of the St. Johns River, blacks became accomplished woodsmen, hunters, and fishermen. The Snow Hill and Curryville community along the Econlockhatchee River was the site of annual Seminole celebration of the green corn dance. Historians speculate that slaves who escaped from plantations and joined the Seminoles also attended these ritual gatherings. Old Seminole fields and groves were found in the 1880s at Snow Hill and Curryville. The Seminoles were cattlemen, but historians say they learned many of their farming skills from escaped slaves. The United States, which acquired Florida in 1821, moved Army troops and supplies along the St. Johns and other rivers during its campaigns against the Seminoles and their black allies, many of whom had originally been captured from Africans. The Seminoles welcomed them as capable warriors and skilled farmers and allowed them to form their own villages. Many would be sent to the reservations west of the Mississippi River.

# BLACK AMERICA SERIES

# SEMINOLE COUNTY

*Altermese Smith Bentley*

9.23.01

Copyright © 2000 by Altermese Smith Bentley
ISBN 0-7385-0634-6

Published by Arcadia Publishing,
an imprint of Tempus Publishing, Inc.
2 Cumberland Street
Charleston, SC 29401

Printed in Great Britain.

Library of Congress Catalog Card Number: 00-107236

For all general information contact Arcadia Publishing at:
Telephone 843-853-2070
Fax 843-853-0044
E-Mail sales@arcadiapublishing.com

For customer service and orders:
Toll-Free 1-888-313-2665

Visit us on the internet at http://www.arcadiapublishing.com

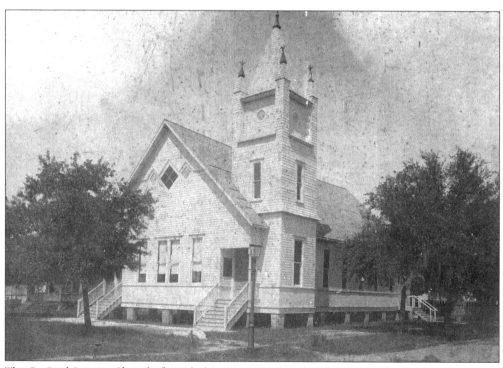

The St. Paul Baptist Church, founded in 1878 in a brush arbor in Sanford's Georgetown, is the oldest Baptist church established by the pioneer African-American families. This sanctuary, which replaced a log cabin, was built in 1889 at Ninth Street and Pine Avenue. The trustees at that time included Smith Burnett, Altermese Smith Bentley's grandfather.

# CONTENTS

Acknowledgments 6

Introduction 7

1. The North Seminole Communities 9
   *Georgetown, Goldsboro, Sanford Heights, Lockhart, Bookertown, Midway/Canaan, and Markham*

2. The Oviedo Area Communities 101
   *Lawtonville, Washington Square, Jackson Heights, Johnson Hill, The Square, Boston Hill, Snow Hill, Geneva, and Jamestown*

3. The Altamonte-Longwood Area Communities 117
   *Winwood/East Altamonte, and Longwood*

4. Epilogue 128

# Acknowledgments

This book would not have been possible without the early support of Seminole Community College's Dorothy Morrison and Dr. Stephen C. Wright. It is also important to give thanks to the contributions from local churches, schools, social organizations, community groups, and families who are the keepers of our oral history. I am greatly in debt to many people throughout the communities of Seminole County. Special thanks are given to Alicia Clarke of the Sanford Museum, Karen Jacobs of the Museum of Seminole County History, and the members and staff of the City of Sanford's Historical Preservation Board. Many of the agricultural subjects of the early Seminole County scenes were borrowed from the collection of Ensminger Brothers Photographers of Sanford. Too much cannot be said about the individual families who opened their treasurers of keepsakes to help preserve and document our heritage. I take this opportunity to thank these people: the Charles Gray family, the Oliver family, Ollie Belle Lowman II, Paul Sedro, Claudia Sims, Annye Louise Refore, the Walden family, Betty Robertson, Walter (Conyers) Ware, Paul Wright, James Wright Sr., Aileen Gibson, Rev. Blanche Bell Weaver, Agnes Knighton, Bob Thomas, Marva Hawkins, Doretha Fogol, Francis Coleman Oliver, Edlena James, Roberta Terry, the Glover family, Daphney Humphery, Patricia Merritt Whatley, Beatrice Thompson, and Ruth Johnson Allen. Lastly, I extend my sincerest appreciation to Jim Robison for having accepted and guided me through the process of compiling this book. I could not have moved off on such a task without his skills and talents.

# INTRODUCTION

When reporters and historians look for details about African-American life around Sanford and black church life throughout Florida, they are often directed to Altermese Smith Bentley. During her youth, Mrs. Bentley would sit on her front porch in Sanford's Georgetown community and name the people as they passed. Her grandfather, Smith Burnett, built a prior home on the site in 1882. Burnett, a city worker whose job included lighting the downtown street lamps, brought his wife, Susan, and their two small children, Mary and Chaney, to Sanford in the early 1880s. College, followed by 28 years as an educator in Philadelphia, took Mrs. Bentley away from her childhood neighborhood, but in 1975 she returned to the same family house and began writing and collecting photographs to tell the stories of her neighbors. Her goal was to preserve the heritage of the land the city's founder set aside for black laborers and to document an often overlooked aspect of the early days of Seminole County. In her latest work, *Seminole County,* Mrs. Bentley shares the diverse backgrounds of the early settlers of Seminole County, including fleeing slaves who brought to Florida the farming skills they learned on plantations and joined the Seminole resistance, cattle ranchers who opened the remote St. Johns River valley to settlement, and freedmen who founded the first churches and schools. She draws on early letters, church and school records, and census reports to show the social, cultural, and economic influence of those who settled Georgetown and other communities of Seminole County. Often, though, she draws from her own family stories. She and her sister, Eunice Smith Whitehead, followed their mother into careers as educators. Chaney Smith attended grade schools in Georgetown and then the Baptist Institute at Live Oak. She later taught at the school in the Tangerine community on the Orange-Lake county line before her marriage to a man from her school in 1900. Charles J. Smith, who also attended college, worked during the week, and on Sundays, he walked along the railroad tracks to Longwood. He was minister at Corinth Baptist Church, now Mount Olive. Their parents made education a family priority, stressing the need to excel. Segregated schools and meager budgets for teacher salaries and classroom materials were major obstacles in Georgetown. Parents bought the books and supplies for their children. Teachers paid for other materials or raised the money from the community. "The stinginess of white legislators made getting an education a great challenge for most blacks, but this led to an increased drive to achieve," Mrs. Bentley writes. "These disadvantages did not stand in the way of parents of Georgetown. The most was made of the facility at hand." Mrs. Bentley received her bachelor's degree from Shaw University, Raleigh, NC, and her master's degree from Pepperdine University, Malibu, CA. She retired from the Philadelphia school district in 1975 and returned to her family home in Sanford.

—Jim Robison, July 2000
Co-author of *Flashbacks, The Story of Central Florida's Past*

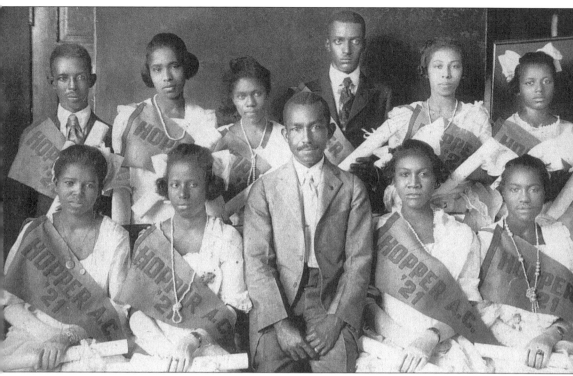

This photograph, also on the cover, shows the graduates of the 1921 Class of Hopper Academy. Hopper Academy, which has just been restored as a community center, is Sanford's oldest standing school built for black students. It also is one of three buildings in Georgetown included on the Florida Black Heritage Trail. It opened a few years before Seminole County was carved out of Orange County in 1913. Located at Eleventh Street and Pine Avenue, it is situated a few blocks south of the site of the original Georgetown School, which was built at the northeast corner of Seventh Street and Cypress Avenue in 1885 with $100 from the school board.

# One
# NORTH SEMINOLE COMMUNITIES

*The first permanent black communities of Georgetown and Goldsboro came after the Civil War, when Sanford was the region's commercial and railroad hub. Georgetown, the premier African-American community of historic Orange County, which included Seminole County until 1913, was settled by pioneer black families on lots Henry Sanford sold them. In a February 18, 1890 letter to his son, Sanford traced Georgetown's beginning to the 60 black workers he brought from Madison to clear land for groves and plant citrus. "They were driven off and some slain with shot guns; and to that very act, the Georgetown suburb of Sanford owes its existence for when I was strong enough to defy the shotgun policy men, I offered and secured a home and protection there to peaceful, laborious, worthy colored people—they have fulfilled my expectation." Goldsboro residents and those from other areas of the northern end of the county cleared the land for farms and citrus groves, ran the steamboats, and worked on the docks that made Sanford's Lake Monroe the leading gateway to Florida's wilderness interior. From the early black settlements came those who laid the tracks, then fired the boilers that turned the wheels of trains on newly opened railroads. The first African-American families opened the first black-owned businesses in Central Florida and established family traditions that shaped their communities.*

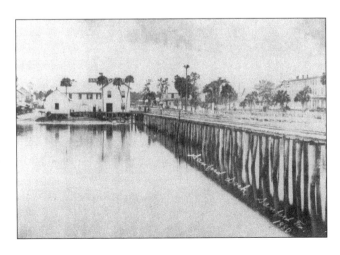

Much of Central Florida's prosperity can be traced to the toil of the black laborers who staffed the steamboats that made Sanford's Lake Monroe the leading gateway to Florida's wilderness interior.

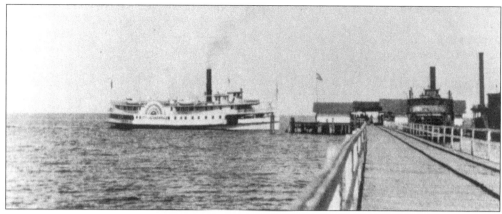

*The City of Jacksonville*, one of many steamboats on the St. Johns River, docks at Sanford's wharf on Lake Monroe in 1896. Mellonville, which later became part of Sanford, was "where civilization stopped," as one newspaper writer put it in an 1850s article about the steamboat lines along the St. Johns River. As the southernmost point that steamboats could reach along the St. Johns River, Mellonville grew as a destination point for settlers when the state opened vast swampland and prairies to homesteaders.

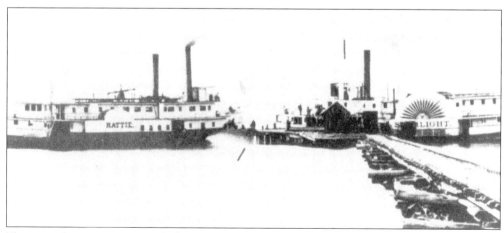

The riverships *Hattie*, *Starlight*, and *Florence*, shown here about 1900, were steam-powered, filling the air with coal smoke as they plied the winding St. Johns between Jacksonville and Sanford, making it possible for settlers to buy supplies at a reasonable price and ship their produce to distant markets.

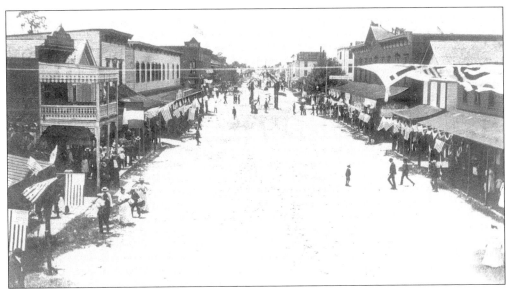

This is Sanford's First Street looking west from Sanford Avenue during a Fourth of July celebration before a fire in 1887 burned down most of the wood-frame buildings.

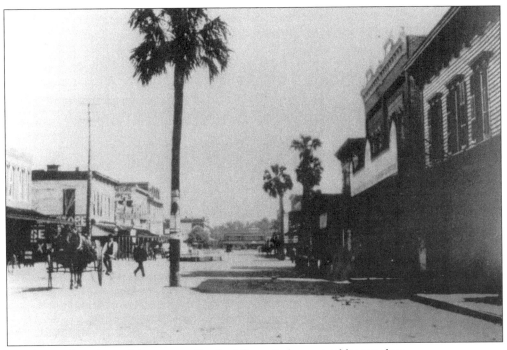

Here's another view of downtown Sanford from its horse-and-buggy days.

The Eichelberger Funeral Home is shown at its original site at Ninth Street and Locust Avenue. It was one of many Georgetown and Tuckertown businesses. Wofford Tucker bought 50 acres on the southeast shore of Lake Monroe in the late 1860s. These early black-owned businesses along Sanford Avenue were the first in Central Florida and established family traditions that shaped their communities. Tucker built a slaughterhouse and meat packing plant. Most of his workers were black and built a community of thatch-roofed homes. People of means didn't build their fine houses along the lakefront. The lakefront was lined with steamboat wharves, railroad docks, fish markets, warehouses, and meat packinghouses. One of the first black-owned businesses was a restaurant. Others entrepreneurs opened boardinghouses, barbershops, a livery stable, a drug store, lunchrooms, clothes cleaners, grocers, and others shops.

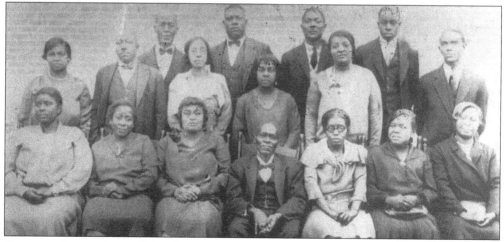

Here are the members of the Georgetown Community Choir in the 1920s. The men and women included representatives from many area churches.

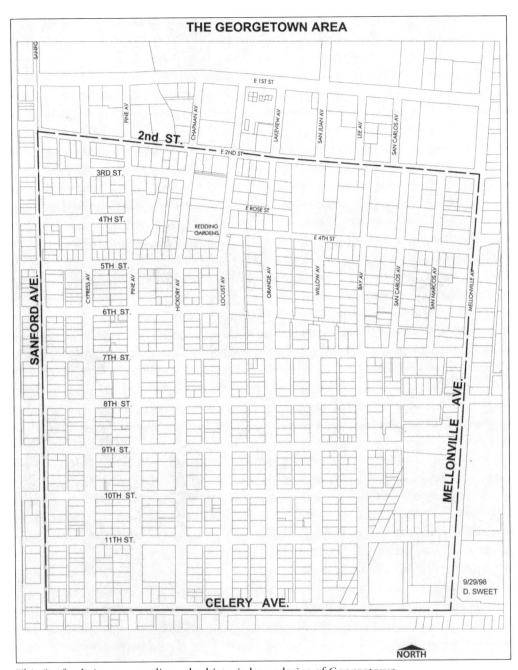

This Sanford city map outlines the historic boundaries of Georgetown.

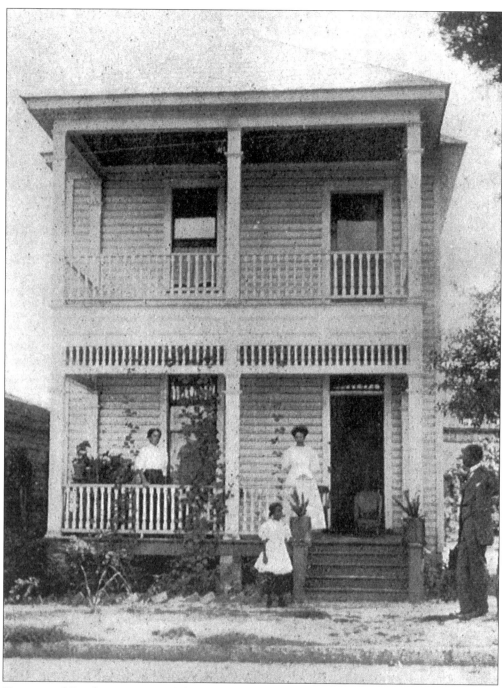

Montez and Frank Harris owned this house, which is now used by GoldenRule Housing and Community Development Inc. at 417 E. Second Street. GoldenRule, which builds affordable housing, bought the house and the Harris' rental properties after the Harris estate passed to the United Negro College Fund.

Montez Harris was issued this certificate as the lay delegate to represent the Orlando area at the 1944 annual conference of the African Methodist Episcopal Church in Philadelphia.

This deed shows that Frank and Montez Harris paid $250 in 1901 for their lot on the edge of the Tuckertown business district and the residences at Georgetown. Frank Harris, ran the janitorial services for M.F. Robinson's Welborn block of businesses in downtown Sanford, and his wife, a teacher, invested in real estate.

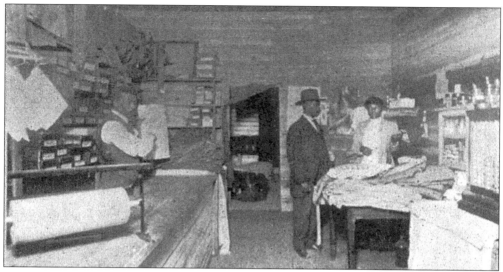

The Rev. K.S. Johnson owned this grocery and drygoods store at 323 Sanford Avenue. He teased his family that K.S., which stood for King Soloman, really stood for "Keep Sweet." He studied agriculture at Tuskeegee Institute and had several businesses, including a laundry, an undertaking business, investing in real estate, and doing brick and pottery work. He and another businessman provided the bricks for the historic St. James African Methodist Episcopal Church and made the railings for the church's steps. He also made the railings on the family home on Cypress Avenue. When the grocery store on Sanford Avenue burned, Johnson opened a new store in Goldsboro. Ida Gardener ran the store for him. He met his future wife, Elizabeth, when he was teaching agriculture at Eatonville's Hungerford School. Her maiden name was Johnson, too. She trained to be a seamstress and hairdresser, and did Zora Neale Hurston's hair when the writer was living in Sanford.

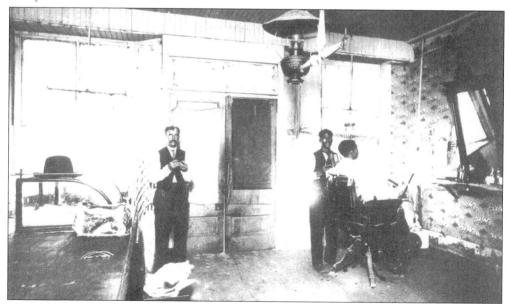

This scene of Frank E. Eaverly's barber shop and watch repair was taken in about 1910. The shop was at 110 S. Sanford Avenue.

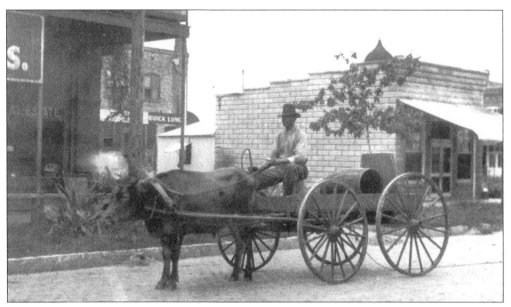

In the early 1900s, mules and oxen pulled wagons built low to the ground for easy loading and unloading. The drayman with the ox-drawn cart is traveling along First Street west of Park Avenue. Just the top of the railroad's Pico Hotel can be seen behind the building in the background. The man driving the celery wagon along Second Street at Palmetto Avenue is William Taylor, who worked for celery farmer O.J. Pope, whose fields were along Celery Avenue. The young boy behind the wagon is Fred Pope, son of the farm owner.

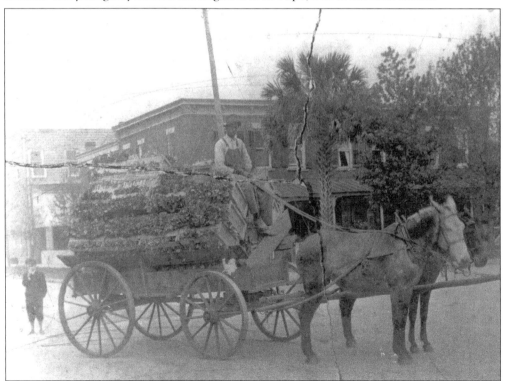

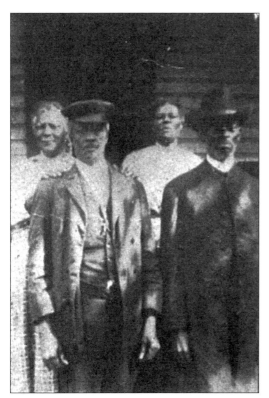

The Rev. A.E. Irvin, shown here at the far right with his wife and friends, and in front of his house at Eighth Street and Hickory Avenue in Georgetown in the picture below, was born into slavery on a Georgia plantation. In Sanford, he owned an orange grove and ran a shoe-making business from a shop next to his two-story house. His stepsons, Nathan and S.D McGill, became lawyers.

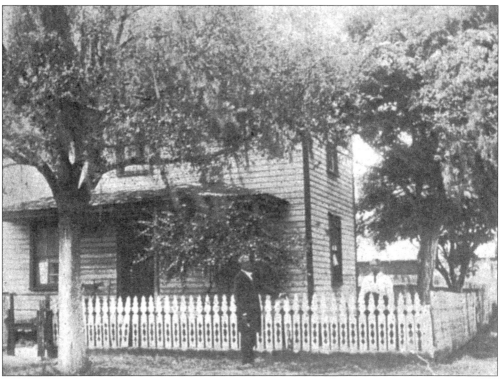

Nathan McGill was among the Southern black young people who migrated to Chicago and other northern cities. McGill grew up under oaks that shaded the houses at Eighth Street and Hickory Avenue in Georgetown community of Sanford. He followed his brother, Simuel Decatur McGill, into a law career. Nathan McGill devoted much of his law practice to defending the rights of young black laborers seeking jobs in the North. He became a crusader against Southern racism and the Northern union policies that denied jobs to black workers. McGill was an attorney for the *Chicago Defender*, a weekly newspaper, working with civil rights leader Claude A. Barnett, who also was born in Georgetown in 1889. Barnett, founder of the Associated Negro Press in Chicago in 1919, was the news organization's director through nearly 50 years of social change. It was the oldest and largest black press service in the United States, growing to include 225 newspapers and magazines for black readers.

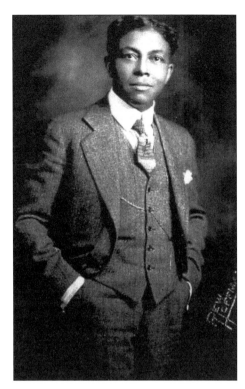

S.D. McGill took his place in Florida law history for winning the freedom of four African-American men sentenced to death after authorities forced confessions to the murder of an elderly white man in Pompano Beach in 1933. McGill's victory came after nine years of civil-rights challenges that won a U.S. Supreme Court ruling that led to the release of the four men from prison in 1942.

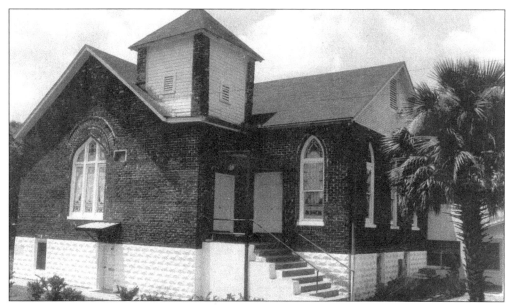

Black architect Prince W. Spears built St. John Missionary Baptist Church, shown here before the engineering that lowered the entire sanctuary several feet the early 1990s so that the older members could get up the steps easier. He also built Trinity Methodist Episcopal Church in the 1920s, New Mount Calvary Baptist Church between 1918 and 1920, the block of brick storefronts on Sanford Avenue between east Third and Fourth Streets in 1912, and a scattering of private homes. His own home at Twelfth Street in Goldsboro has been torn down, but many of the other houses he built remain. When he married Theodocia Purcell on March 25, 1920, his witnesses were Herman Refoe Sr. and Italy Littles. He built the Littles' house. Spears, who is believed to have come to Sanford from Georgia with fellow mason Neal Lofton, is responsible for more than a dozen homes and churches built in the early 1900s. Oral histories say he attended Tuskeegee Institute.

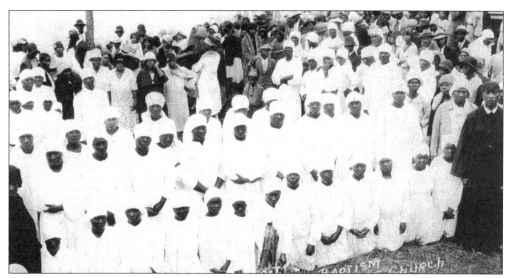

This 1930 photography shows The Rev. H.S. Williams and the congregation of Zion Hope Baptist Church at a baptism on the shore of Lake Monroe.

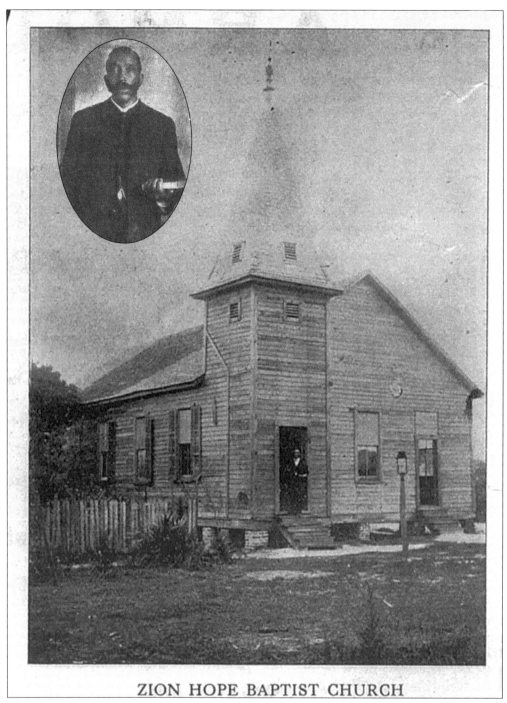

ZION HOPE BAPTIST CHURCH

The Rev. John Hurston (inset) served many area churches, including working as pastor for nearly two decades at Sanford's Zion Hope Baptist Church, shown above as it appeared during his day. Hurston was the father and inspiration for famed writer Zora Neale Hurston. *Jonah's Gourd Vine*, published in 1934, was Zora Hurston's first novel.

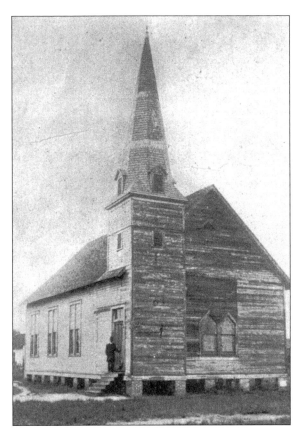

This wood-frame sanctuary is how St. James African Methodist Episcopal Church appeared in the late 1800s before it was replaced. Also shown is the sanctuary as it appears today. St. James, organized in 1867, still serves the community from the sanctuary designed and built by Prince W. Spears. It is listed on the National Register of Historic Places and is one of the Georgetown stops on the Florida Black Heritage Trail. Built at 819 Cypress Avenue between 1910 and 1913, St. James became a "mother church," sending circuit preachers in the 1920s and 1930s to west Sanford, Bookertown, Cameron City, Midway, and the old Fort Reid area of south Sanford.

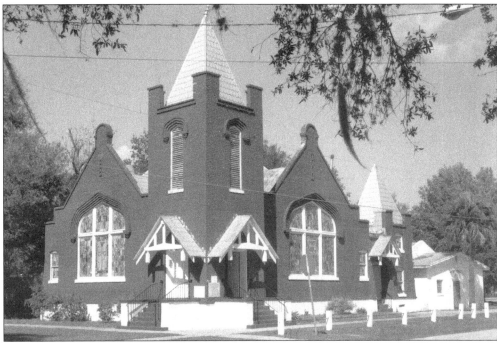

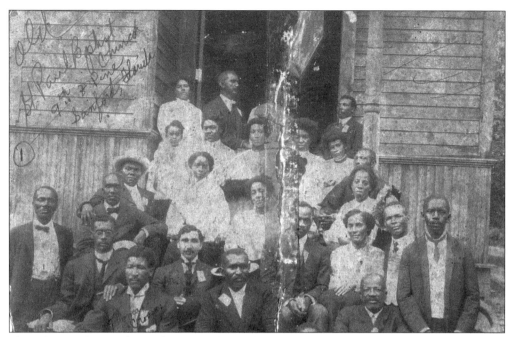

This photo, taken in the early 1900s, shows the congregation and home of Sanford's oldest baptist church, the St. Paul Baptist Church. The church began in 1878 when the congregation worshiped at a bush arbor of palmetto branches until a wooden cabin was built in December 1881 on land purchased from city founder Henry S. Sanford and his wife, Gertrude. It predates First Baptist Church, founded by white settlers in 1884.

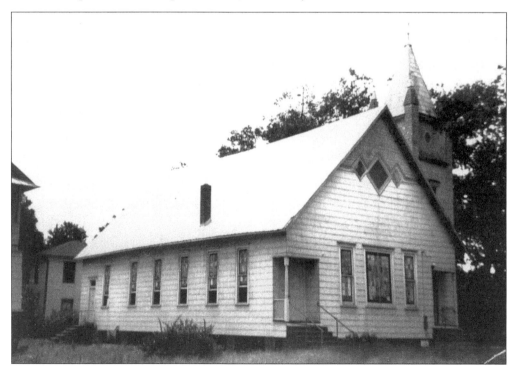

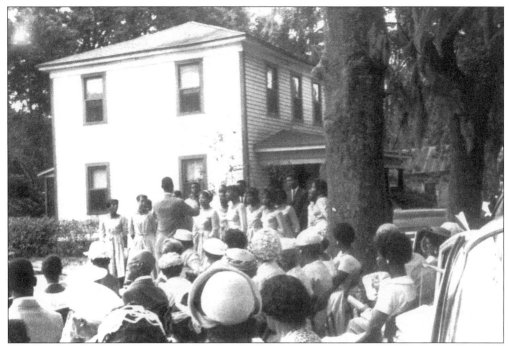

The congregation of St. Paul Baptist Church held its worship outdoors while the new sanctuary was under construction at the same site as the old sanctuary. The home of C.J. Smith is in the background.

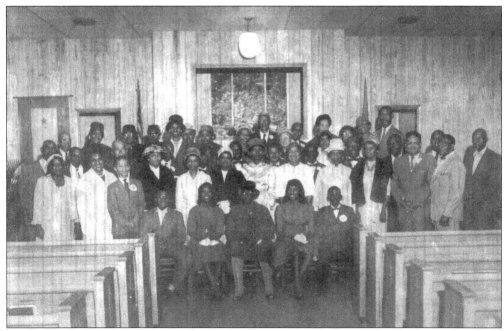

These are the members of St. Paul Baptist Church in the mid-1960s. The Rev. B.F. Hodge, who was pastor when the new sanctuary was built at 813 Pine Avenue, can be seen in the middle of the back row with a flower in his lapel.

St. Paul Missionary Baptist Church was well established when The Rev. Castle Brewer, shown here, came to Sanford from South Carolina in 1894. Under his leadership, the cabin sanctuary was replaced. Land north of the church was added in 1896 for a parsonage. The trustees at that time included Smith Burnett, the author's grandfather, who had come to Sanford in the 1880s as one of many black laborers. A Sanford Housing Authority apartment complex and an avenue in Bookertown are named to honor Brewer. He was pastor at St. Paul from the closing years of the 1800s until the 1930s. His wife, Mary, is pictured in the bottom photograph.

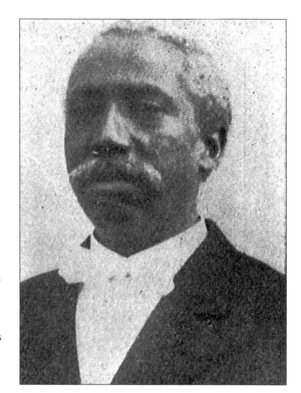

Posing during an Elks Lodge parade at Shepherd Avenue are, from left to right, Ruth Hatch, Osburn Jones, and Ella Sims.

This Women's Club was organized by Belle Mathews and Dr. George Starke to bring together women from all of Sanford's black communities.

D.C. McCoy, shown standing on the far right, owned a dry cleaning business at Thirteenth Street in Goldsboro. With him are the other members of the Young Men's Improvement Association, a professional organization and social club started to motivate young entrepreneurs.

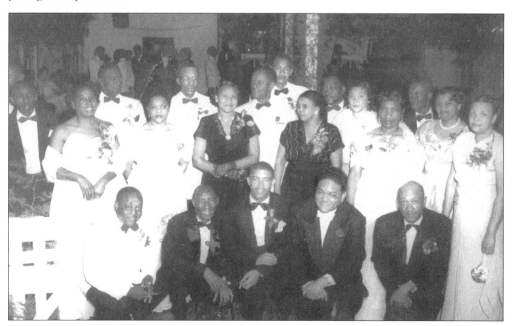

The Sanfonians, shown at one of their formal galas, was a social club for Sanford's business owners and professionals.

## KAPPA RHO OMEGA CHARTERED

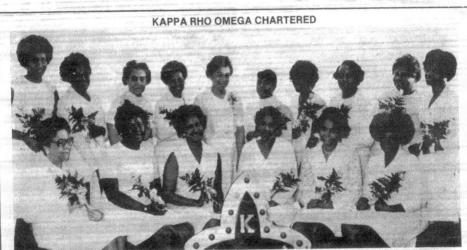

Kappa Rho Omega Chapter of Alpha Kappa Alpha Sorority members and officers: Seated — Sorors Mary Redd, anti-grammateus; Rachel Brydie, Ivy Leaf reporter; Elizabeth Washington, anti-basileus; Letha Mayfield, basileus; Jacqueline Downs, tamiouchos; Jacqueline Armwood, grammateus. Standing — Sorors Helen Stiff, chairperson of Undergraduate Interest Group; Mamie Morris, epistoleus; Connie Rawlins, parliamentarian; Barbara Toney, philacter; Janet Ballard, Mid-Atlantic Regional Director; Grace Forrest, Prenella Mosley, Adalaide Griffin, Marbella Johnson and Ortygia Carnette.

## KAPPA SIGMA OMEGA CHARTERED

Sorors of the new Kappa Sigma Omega Chapter seated from left to right: Elizabeth Young, Mary Whitehurst-Epistoleus, Rebecca Sweets-Basileus, Jeannette Daniels, Carletha Merkerson-Anti-Basileus, Barbara Chambers, Sandra Petty-Hodegus, Ozie Mathis-Reporter-to-the-Ivy Leaf, Zonnye Davis-Financial Grammateus, Parliamentarian, Norma White-South Atlantic Regional Director, Eugenia D. Scott-National Financial Director, Vivian Bowden-Grammateus, Mildred Wright, Angie Douglas-Tamiouchos, Juanita Harold, Geraldine Wright and Louise Smith.

Seventeen Seminole County Alpha Kappa Alpha women realized their dreams of organizing a local graduate chapter of their sorority on April 10, 1976. The Kappa Sigma Omega Chapter of Alpha Kappa Alpha Sorority was chartered by the South Atlantic Regional Director, Soror Norma White, in an impressive 10:00 a.m. ceremony at the Sanford Sheraton Inn in Sanford, Florida.

The occasion had special significance to our National Financial Director, Soror Eugenia D. Scott, a native of Sanford who was able to attend the ceremony while visiting relatives and ceremony, Soror Scott installed the chapter officers.

The culminating activity of the day was the luncheon which followed the installation of officers. The luncheon was attended by sorors from neighboring graduate and undergraduate chapters.

Kappa Sigma Omega is the first graduate chapter of any predominantly Black Greek letter fraternal organization to be established in the Sanford community. It's impact on the civic social, and educational aspects of community life will certainly be impressive.

These are members of the Seminole County chapters of predominantly black fraternal organizations.

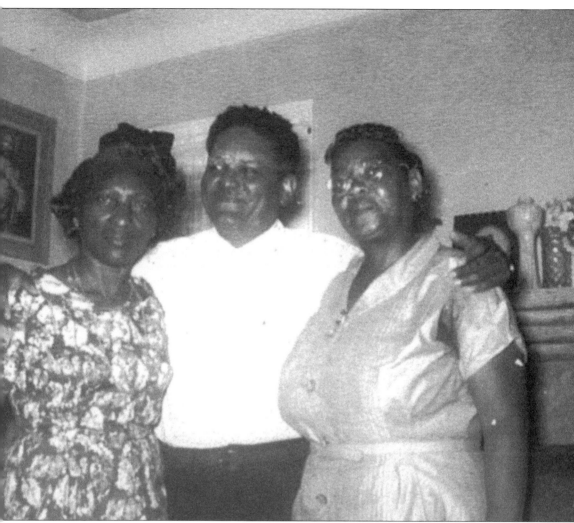

Dr. George H. Starke, his wife, Hattie (left), and Ella Sims pose for a 1955 photograph after dinner at the Sims home at 617 Cypress Avenue. In 1977, the Georgetown doctor was honored for more than a half century as a family doctor and surgeon for the families of Sanford. His father, a farmer in Melrose, encouraged his son to take a railroad mail clerk exam. He passed, and learned that his job would be in Alaska. Instead, he attended Florida A&M College with his brother Lancaster. After graduation, the brothers set off for Detroit. Lancaster worked as a housepainter while Starke found work as an autoworker. Both saved the money they would need to graduate from Nashville's Meharry Medical School in 1927. Starke, who planned to practice in Lakeland, picked Sanford, instead, on the advice of an Orlando doctor. He opened his first office over Jerry's Drug Store on Sanford Avenue. Commerce was good on Sanford Avenue, especially on Mondays and Saturdays when farm people came to town. Dr. Starke and three other black doctors won Harvard University residencies to train at Massachusetts General Hospital. He returned to Sanford in 1933, becoming the first black doctor to join the Seminole Medical Association and the Florida Medical Association. He also opened a clinic at 1011 S. Sanford Avenue. His wife, Hattie, ran the business side of the office. He died in 1978 at his home at 611 Locust Avenue. The 6-acre city park on west Sixth Street honors his memory.

This is Dr. Wilbur Martin, whose father came to Sanford to work for the railroad.

This is the Martin home at 614 Sanford Avenue.

Dr. Martin's sister, Francine Martin, shown in this portrait, was a teacher at Hopper and Crooms Academies.

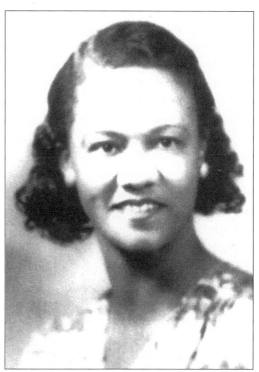

Essie Martin Gramling and relatives gather at the family home at 614 S. Sanford Avenue in 1942. The men in uniform are her son Wilbur and her son-in-law Crosby.

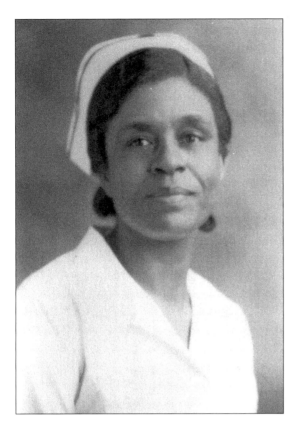

Rachel Lee, shown here in 1940, served the county longer than any other nurse. She lived at east Ninth Street and Sanford Avenue, and worked at the infirmary at the county's retirement home for the elderly. The main building, shown below, and the infirmary are now the Museum of Seminole County History at Five Points. Authorities have applied to have the building added to the National Register of Historic Places.

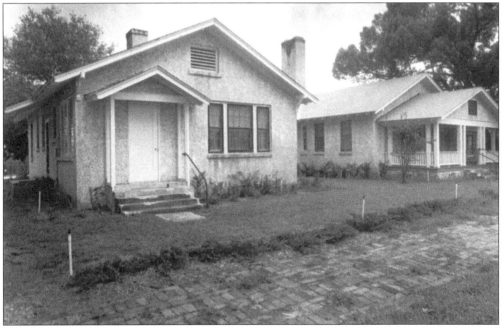

Shown here are two other nurses from the county home for the elderly, Minnie Lomax, who lived at east Seventh Street and Hickory Avenue, and Violette King, who lived on west Twelfth Street near Lake Avenue in Goldsboro.

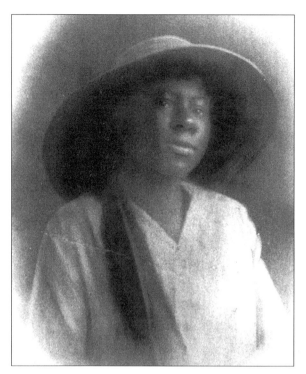

This is a portrait of Patsy Roberts, who worked in the homes of two of Sanford's doctors. She was the aunt of Mae Henry Smith Gilmore. Gilmore owned and operated the area's first birthing center, which was located at Orange Avenue and Celery Avenue.

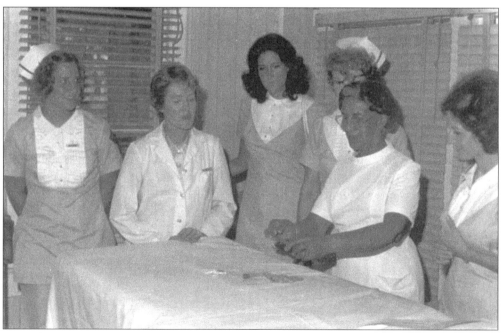

Midwife Marie Francis is shown with some of her students. She trained 25 other midwives during her 40-year career in Sanford. She had raised three children and worked in hotels and restaurants before she became a midwife, which wasn't until after her 40th birthday. After World War II, the state sent her to Florida A&M University in Tallahassee for her training to become a registered midwife.

Marie Francis, left, stands with her sister, Annie Clyde Walker, who also worked at the birthing center at Sixth Street and Hickory Avenue.

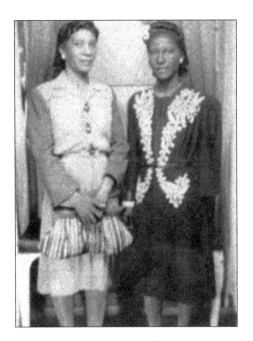

Marie Francis and her sister, Annie Clyde Walker, stand outside the birthing center. Their mother, a nurse midwife, converted the former home of Rev. John Hurston into a two-story clinic. They had beds for five patients, but sometimes Francis gave up her own bed. The house is one of three stops in Sanford on the Florida Black Heritage Trail. Hurston's daughter, writer Zora Neale Hurston, worked on some of her early works in the house.

Mrs. D.C. Brock, shown in 1956, stands at the steps of the Georgetown home that her family opened to black baseball players when they came to Sanford during the spring and summer. The house of real estate broker and tailor D.C. Brock at 612 Sanford Avenue provided a comfortable home to the professional ballplayers who were not welcomed at Sanford's all-white hotels. Jackie Robinson stayed at the house in the spring of 1946.

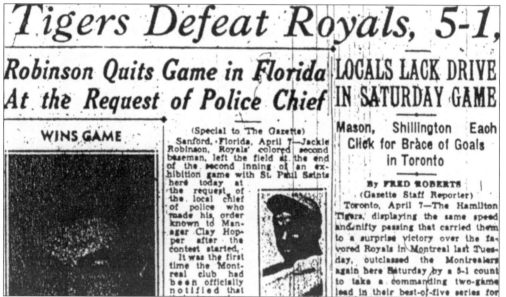

On April 8, 1946, *The Montreal Gazette* told its readers, "Robinson Quits Game in Florida At the Request of Police Chief." Sanford, and just about all of the other Florida towns that spring, did not want Jackie Robinson to compete against white ballplayers. In 1997, Robinson was honored as an African-American sports legend on the 50th anniversary of the first black player in Major League Baseball. But, in 1946, Robinson was playing minor league ball in Florida. On April 7, Jackie Robinson left the field at the end of the second inning of an exhibition game with the St. Paul Saints when the police chief talked to manager Clay Hopper after the game started. "It was the first time the Montreal club had been officially notified that their two colored players, Robinson and Wright, would not be allowed to play here." Robinson had two hits that day. He had already broken the color-line, taking the field March 17, 1946, in Daytona Beach at the first integrated game in professional baseball. Games also were called off in Jacksonville, DeLand, and St. Augustine, and Robinson and his wife, Rachel, were not received well in other cities, including Syracuse and Baltimore.

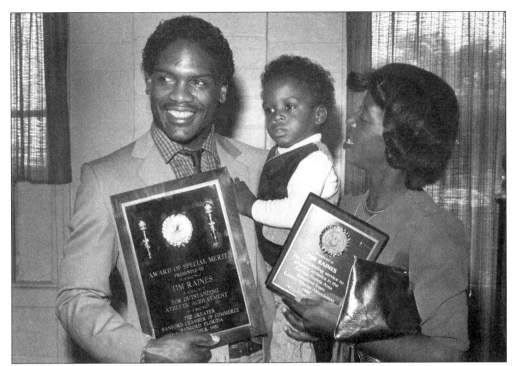

Sanford baseball great Tim Raines, shown above with his wife, Virginia, and their son Tim, has contributed much to his community. His sports-related donations to The Sanford Museum include the 1946 baseball card showing Jackie Robinson in the Montreal Royals union he wore when his minor league team played in Sanford. Raines, who recently retired from the New York Yankees and lives in the Sanford area, is shown below batting for the Montreal Expos.

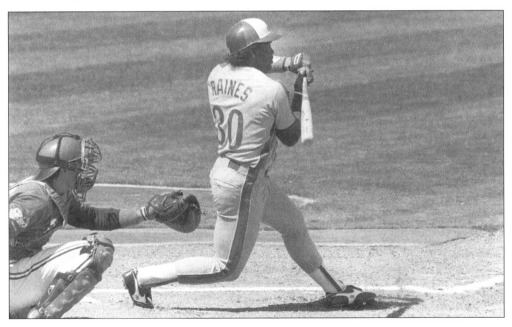

Sanford's favorite sporting sons include Seminole High graduate Jeff Blake, a Heisman Trophy candidate during his senior year at East Carolina University and nine-year veteran as an NFL quarterback for the New York Jets, Cincinnati Bengals, and the New Orleans Saints.

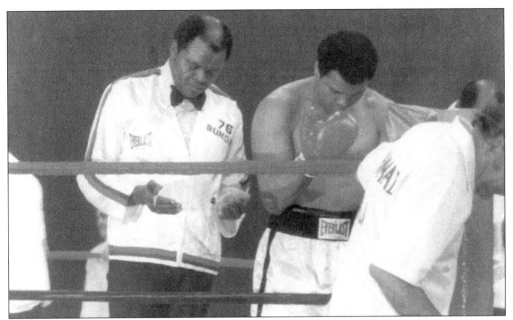

Also among Sanford's sports personalities is Drew "Bundini" Brown, long-time corner man for boxing legend Muhammad Ali, shown here with Brown during a moment of prayer just before a fight. Brown, who grew up in Georgetown, joined the Merchant Marines when he was 13. Before signing on as Ali's assistant trainer in 1963, Brown worked for other boxers, including Sugar Ray Robinson.

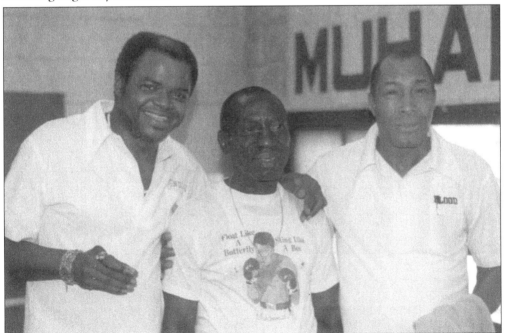

Georgetown-born Drew "Bundini" Brown, shown on the left with two other men who worked with Muhammad Ali, is credited with coining the famed Ali phrase, "Float like a butterfly, sting like a bee."

Cooks stand over barbecue pits preparing the main course for Sanford's Farmers' Day celebration, an annual event held at the lakefront that drew farm workers from throughout the region.

A fisherman identified only as Shag in records kept by the Chase family played an important role in mid-April 1913, when Sanford residents celebrated after the governor signed the law creating Seminole County from the northern portion of Orange County. Shag, who often appeared at public gatherings in an old Cuban military uniform jacket, blue pants with red stripes down the seams, and an old military cap with a plume, was in charge of firing the old canon from Sanford's Fort Mellon days during special events. But, this time, Shag overloaded the cannon, and it blew apart when fired from the lakeshore. The largest surviving piece of the barrel is buried in front of the Greater Sanford Chamber of Commerce building as a flagpole stand.

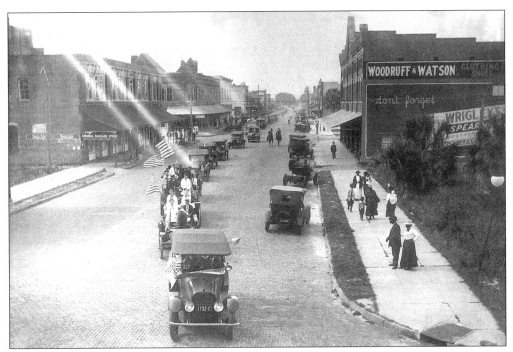

Georgetown residents gather along First Street for this downtown Sanford parade for a Fourth of July celebration in the early 1900s.

Ollie Belle Oliver Williams and her brother, Lowman Oliver, whose mother ran a grocery Store at Eighth Street and Sanford Avenue, grew up in his house at 806 Cypress Avenue. The house was built in the late 1800s to early 1900s. Ollie Williams returned to live at the house after she retired as a social worker for the New York City housing authority.

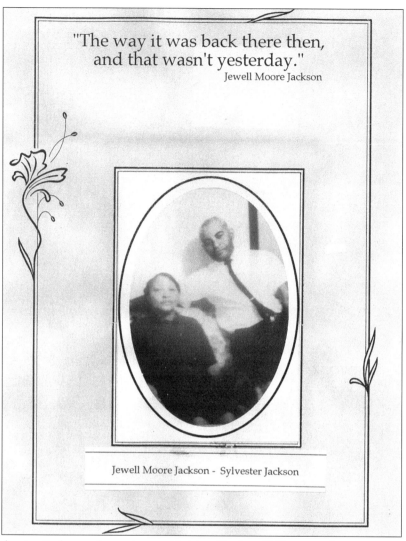

> "The way it was back there then, and that wasn't yesterday."
> Jewell Moore Jackson

Jewell Moore Jackson - Sylvester Jackson

Damon Sylvester Jackson, shown here with his wife, Jewell Moore Jackson, in a page from their daughter's two-volume genealogy of their families, walked from Georgia to Sanford in mid-1934. He wrote to his wife to bring their two daughters by Greyhound bus after he started working on the Lake Monroe docks unloading riverboats. On May 6, 1993, one year and a day after the death of her mother, Mary L. Jackson Fears finished a 13-year search to document her family heritage. In the estate records of Georgia planter John McCrary, she found "my kinfolk's," the family of a slave named Luveser McCrary. Separated by seven generations from African ancestors, Fears had traced her family link from Luveser McCrary to freedom. The story is told in *Slave Ancestral Research, It's Something Else* and the companion book, *The Jackson-Moore Family History and Genealogy*. Fears sites J.N. Crooms, whose parents were slaves on a Tallahassee-area plantation, as her mentor. On his recommendation, she won a scholarship to Bethune-Cookman College in Daytona Beach. The first in her family to graduate from college, she went on to earn a master's degree in library and information science from Florida State University. She retired after 30 years as a librarian in the Volusia County School District.

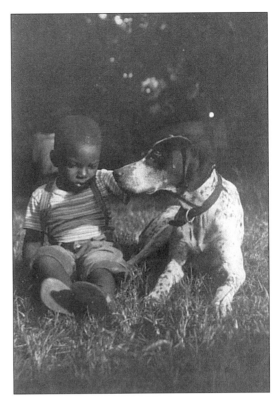

J.C. Sims pets his best pal, King, on October 15, 1949, as they relax on grass. King was J.C.'s first dog. The pointer bird dog was six years old when this photo was taken. This gentle scene shows that good times can follow bad. J.C.'s grandmother, Laura Hall Sims, was one of the Rosewood survivors. A white mob in 1923 sparked a racial violence in which six blacks and two whites were killed and the black community of Rosewood, including homes, a church, Masonic hall, and a store, were burned to the ground. J.C.'s grandfather, Anderson Sims of Alachua County, came to Sanford to work for the railroad and live with his older brother, Charlie Martin Sr. Anderson Sims later worked for furniture store owner T.J. Miller. He learned the business and saved enough money to open his own grocery store at the northwest corner of Seventh Street and Cypress Avenue. The Sims raised 10 of their 12 children at 615 Cypress Avenue.

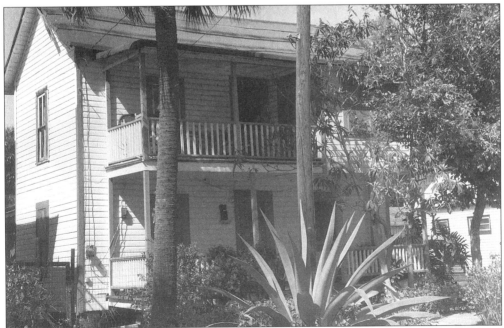

Oscar Gramling opened a barbershop exclusively for white customers on the westside of Park Avenue in downtown Sanford. He lived in this house at 714 Cypress Avenue, which was built between 1885 and 1895. His son Albert continued the business at several locations.

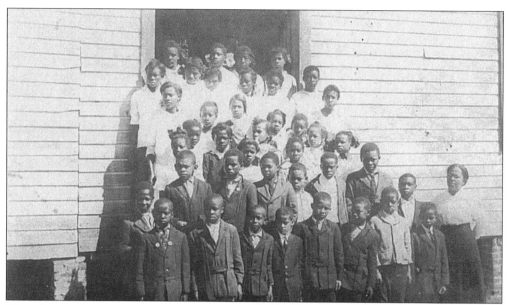

This photo taken in 1910 shows Hopper Academy's third grade students at the original schoolhouse. Teacher Montez Harris stands with a white blouse at the far right. The primary school at Seventh Street and Cypress Avenue is now the Celery City Elks Lodge #542, 619 Cypress Avenue.

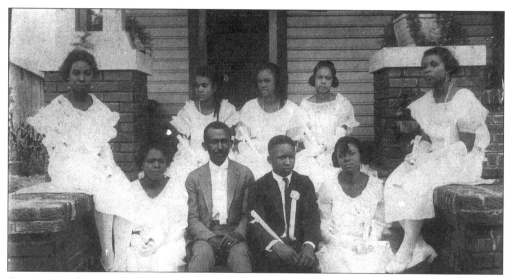

Crooms Academy in Goldsboro linked all the communities of Seminole County. The 1929 graduating class of Crooms Academy sits for this photograph with the school's principal, J.N. Crooms, on the steps of his Georgetown home at 812 Sanford Avenue. Among the graduates of Georgetown School, Hopper, and Crooms Academies were those who went on to become lawyers, nurses, doctors, dentists, musicians, bandleaders, and business leaders. The one who left behind the biggest legacy, though, was Joseph Nathaniel Crooms. The histories of Hopper and Crooms Academies are intertwined in the pioneer Sanford families. Crooms, known throughout the state, was the principal at Hopper Academy in Georgetown from 1906 to 1926. He and his schools touched the lives of many of the early families.

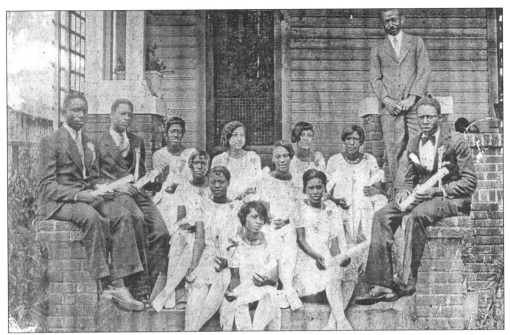

This is another of the Crooms Academy graduation photographs. These 1930 graduates gathered with their diplomas and their principal, J.N. Crooms, at his Sanford Avenue home.

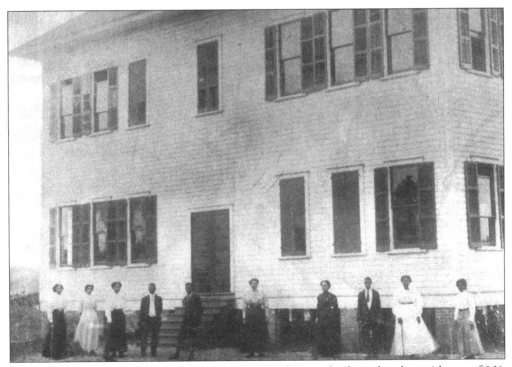

The Hopper Academy schoolhouse that stands today was built under the guidance of J.N. Crooms, shown fourth from the left with the faculty, on the site he selected in Georgetown at 1111 S. Pine Avenue. It was built between 1900 and 1910.

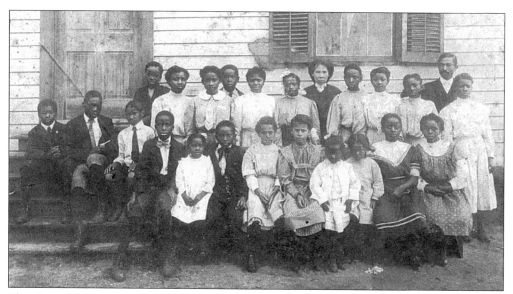

The date of this photograph of Hopper students is not known, but it shows J.N. Crooms, at the top right, and wife, Wealthy Mabel Crooms, in the dark dress in the middle of the top row. Mrs. Crooms inspired others to become teachers. Parents through the 1940s paid Lillie Bell Merthie 35¢ a week to teach their children. Before public schools opened kindergartens for young black children, Merthie taught her own children around a dining room table in the Lockhart house built by her grandfather, a carpenter, on Alexander Avenue. Other parents in Oviedo and Midway brought their children to her house. In the late 1940s, she opened a day care center in Sanford and hired more teachers. She later said she was inspired by her former teacher, Wealthy Mabel Crooms. "She was a very stern person," she recalled. Fifty years later, the community honored her at a banquet. Merthie Drive, formerly Persimmon Avenue, is named in her honor.

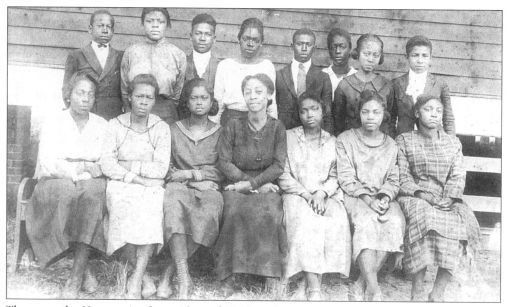

These are the Hopper Academy Class of 1920 graduates.

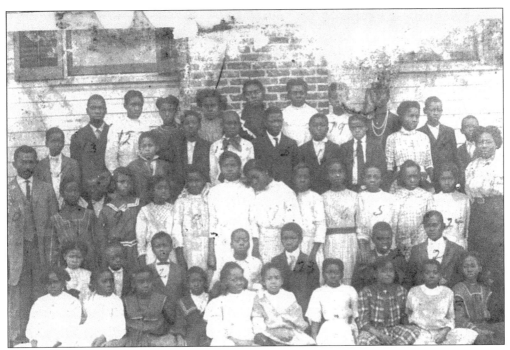

Wealthy Mabel Crooms is shown here on the right with her husband, J.N. Crooms, on the left. The date of this picture of Hooper Academy students is not known.

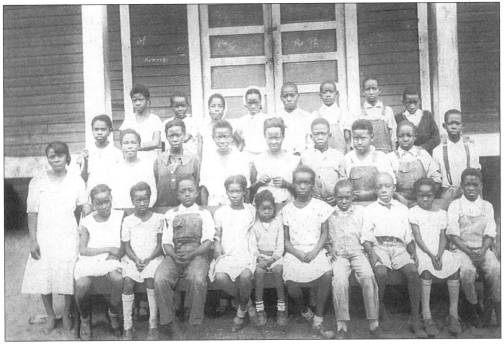

Hopper Academy teacher Josephine Graham, seen here standing in the white dress, attended the school as a student. Her civic work included teaching crafts and canning to community groups.

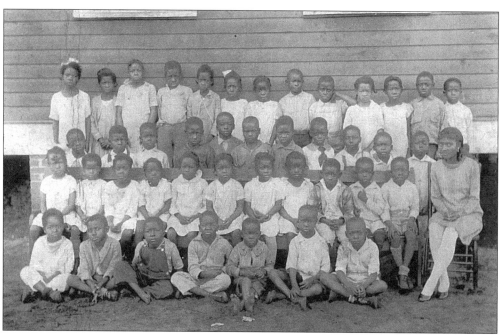

Teacher Lillie Hall Williams is shown here with her students at Hooper Academy. The date is not known.

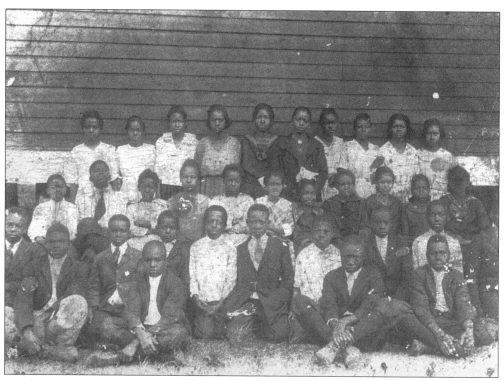

Teacher Mary Elizabeth Bryant stands in the top row, sixth from the right, with her fourth grade students in September 1921 at Hooper Academy.

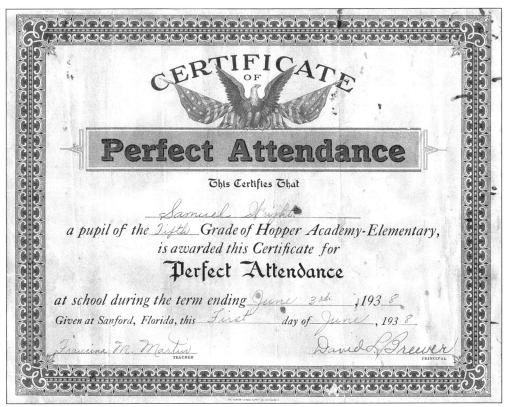

Samuel Wright received this Certificate of Perfect Attendance in 1938 when he was in the fifth grade at Hooper Academy. Teacher Francina M. Martin and Principal David L. Brewer signed it.

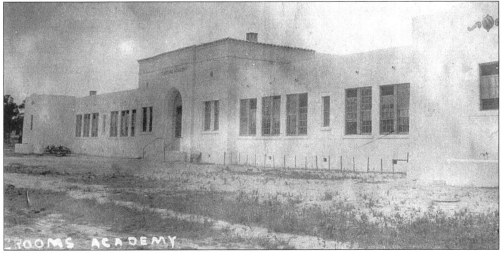

This is Crooms Academy soon after it opened. J.N. Crooms became principal of his namesake school in 1926 with his wife, Wealthy Mabel Crooms, as assistant principal. Crooms Academy on West Thirteenth Street in Goldsboro was the first in Sanford for black students who went beyond the tenth grade. It remains a point of pride in Sanford.

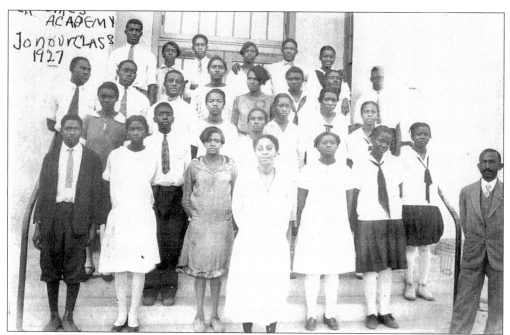

These are the members of the junior class in 1927. The following year, they became the first graduating class of Crooms Academy. The school represented the efforts of many parents. The better jobs were not open to black residents, and lower wages meant poor educational facilities, low self-confidence, and less political power. Still, many Georgetown parents found ways to provide an education for their children. "Preschool education was not overlooked," Eunice Smith Whitehead said. "Miss Peachie Kirby taught a class in her home. Our parents paid 25¢ a week for us to attend."

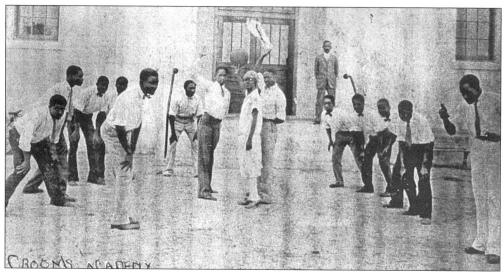

On the steps of Crooms Academy, the players on the 1927 basketball team gather for a team photograph as their principal, J.N. Crooms, watches from the back. The school did not have a gym until 1962. Before that, all sports and physical education classes were held outdoors. Basketball games were played at night on an asphalt court with spotlights.

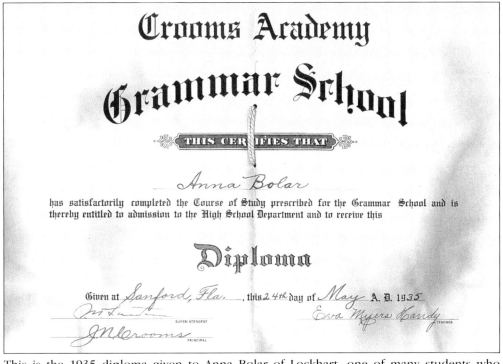

This is the 1935 diploma given to Anna Bolar of Lockhart, one of many students who studied under the direction of Crooms Academy principal J.N. Crooms.

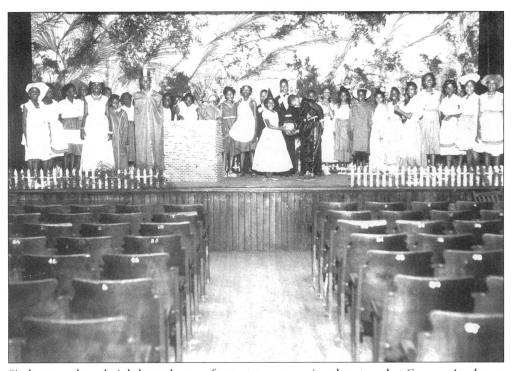

Sixth, seventh and eighth graders perform at a community play staged at Crooms Academy.

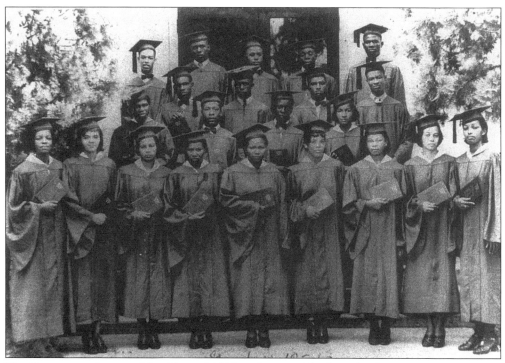
The Crooms graduates of the Class of 1939 gather outside the school.

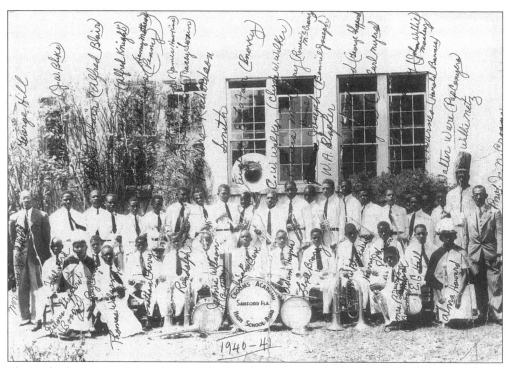
The 1940-41 Crooms Academy High School Band poses with band director George Hill on the left and principal J.N. Crooms on the right.

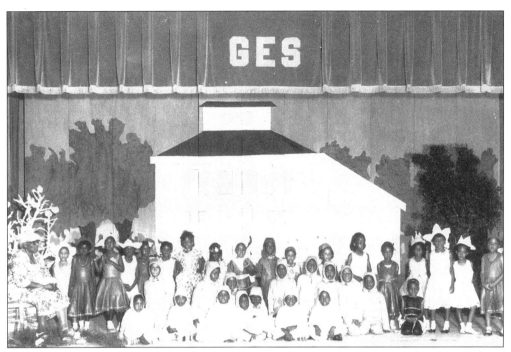

Goldsboro Elementary School principal Joanna Moore, shown seated, watches her students perform during a community play at the school in the mid- to late 1950s.

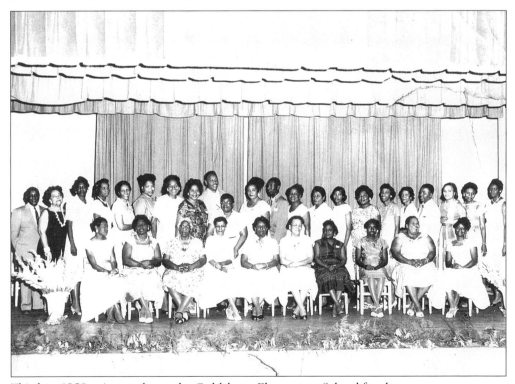

This late 1950s picture shows the Goldsboro Elementary School faculty.

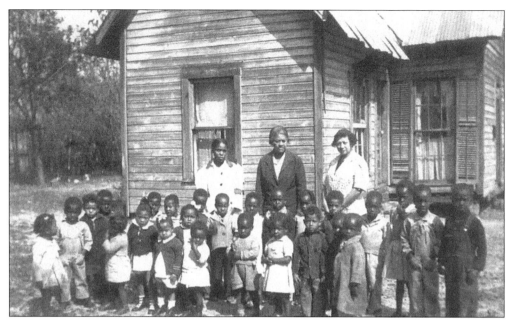

This 1940s photo shows Elizabeth Brewer Bass (in the middle with the dark jacket) surrounded by Goldsboro children. The widow of early Sanford's Dr. George Brewer, she taught music and dramatic arts.

Postcard images of Sanford's children were a popular souvenir sold by the Ensminger Brothers Photographers at their Sanford shop.

Francis Coleman Oliver grew up in Sanford before the dawn of the Civil Rights movement. "We all were poor and didn't know it. We all were depressed and didn't know it. We were segregated and didn't know what it meant," said Oliver, who became an elementary school teacher in Altamonte Springs and Midway, as well as a community activist. "We were a community and the community protected the children." Her parents came to Florida from Alabama in 1946. Two years later, she started school with nine others at the Wagner one-room school near Oviedo. Thelma Franklin was the teacher for the ten students. "We had no lunchroom, outdoor toilet and an iron heater that sat in the middle of the floor." Two years later, her family moved to the westside of Sanford, but she had the same teacher, this time at Goldsboro's Little Red School, which had more teachers and children. The site is now Goldsboro Elementary School. "The westside was the very poor farming area of Sanford," she said. "Most grown ups worked in the fields, cutting celery, picking beans and oranges. On Saturday the kids would go into the fields to pick beans and pack celery. Field work was the only work available to teenagers and young people. If you were lucky you could work in a white person's house or wash dishes in a cafe. The houses were mostly shotguns with outdoor toilets, no running water or heat." In the 1950s, the city's public housing apartments allowed residents of the westside to have as good or better housing than those living on the eastside, she said. "Black-owned businesses in Sanford were at their peak," she said. "I remember Snow's Restaurant, The Star Movie Theater, The Do Duck Inn, Reviling Soda Shop, Scorcher's Soda Shop, The Hole in the Wall, Jimmy's Grocery Store, McCoy Cleaners, Quality Cleaners, and Green's Barber Shop. Fish markets, service stations, and poolrooms were black-owned businesses on Southwest Road and Sanford Avenue. There was a black-owned hotel called McAllister's and a black-owned taxi cab company called Brooklyn Boys Club. These businesses boomed because Sanford was totally segregated. We didn't eat, sleep, go to school, or play with white people. I only saw the outside of white businesses. We had our own corner grocery store because our parents were not allowed to shop at any of the white-owned stores that were not in the black community."

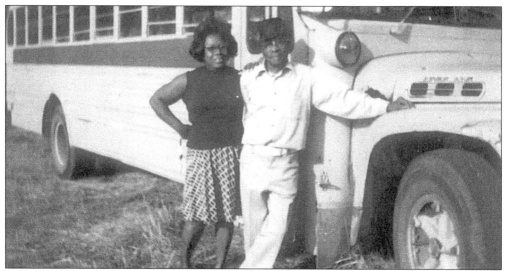

In the 1940s, when Sanford's vegetable farmers faced a labor shortage, some farm workers lived at a tent city at Tenth Street and Olive Avenue in Sanford. Goldsboro neighbors pitched in to help the 147 workers from Mississippi who lived in the tents. The camp grew to 350 workers, many from the Bahamas. "Bud" Gibson is shown with his wife, Aileen, by his crew bus in which they carried workers to farms. His sister, Amanda Gibson Tucker, also used a truck to deliver meals to the workers at Zellwood in west Orange County and the Black Hammock area near Oviedo. During the summers, Gibson drove crews of workers to farms in New York state. Alice Branson Mathis spent her winters in Florida and her summers in Rochester, NY. Mathis earned her living as a seasonal farm worker, harvesting celery behind a mule train in the fields south of Lake Monroe and packing vegetables in western New York state. She was one of the more than 40,000 black workers from Southern farm communities who moved to Rochester in the two to three decades following World War II. The largest share of them came from Sanford.

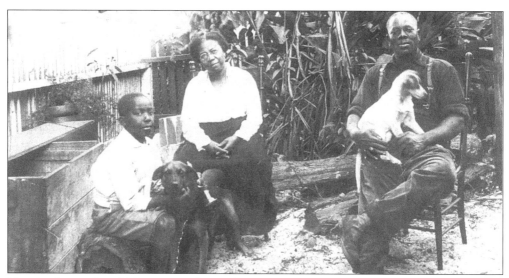

The Boykins of Goldsboro are shown here. William Boykin was one of Goldsboro's postmasters. His wife held the title of postmistress.

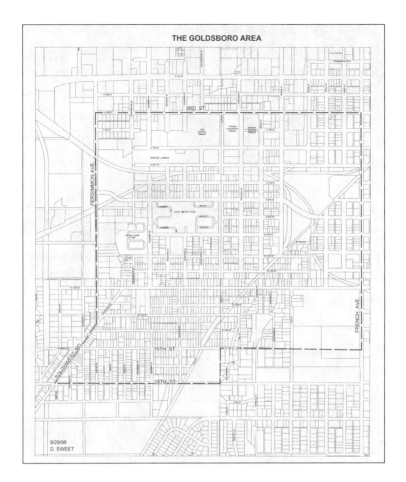

This Sanford city map outlines the historic boundaries of Goldsboro. The west Sanford community was once an incorporated town. Many of the residents were employed by the nearby railroad yard where thousands of carloads of citrus and celery were loaded for markets in the North. Others worked in the fields, groves, and the icehouse and produce-packing houses. Notices for the planned town ran in the *Sanford Journal* from October 24 through November 26, 1891. Registered voters in what had been the village of Goldsboro met on December 1, 1891, at the store opened by William Clark in 1886. They approved a plain seal with the words "Town of Goldsboro." The first elected town officials were Mayor Walter Williams, Aldermen David Wilson, A.T. Shepard, J.A. Williams, E.C. Carolina and Hubbard Jewett, Clerk J.W. Small, Marshal W.W. Clark, Treasurer Joseph White, Tax Assessor J.W. Small, and Tax Collector W. M. Clark. The Town of Goldsboro blocked the City of Sanford from expanding to the west. On April 6, 1911, the City of Sanford passed a resolution to absorb Goldsboro. When the town would not voluntarily give up its charter, Forest Lake, then a state senator, persuaded the legislature to take away the charters of Sanford and Goldsboro and reorganize Sanford to include Goldsboro. The legislature also stopped a group of Sanford Heights residents from continuing efforts to incorporate that neighborhood south of Celery Avenue. The legislature passed the Sanford Charter Bill on April 26, 1911. Sanford pledged to pay Goldsboro's debts within 90 days, but Clark told Hurston in 1936 that he still held "a mass of jumbled yellow papers" representing $10,375.90 in unpaid debts. Sanford changed the names of Goldsboro's streets, including renaming Clark Street as Lake Avenue for the man who engineered the town's demise.

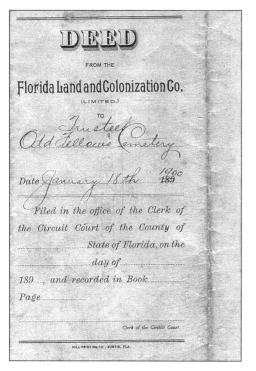

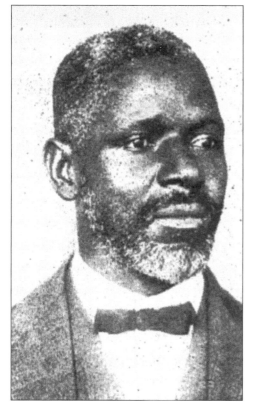

This deed transferred land off Twenty-fifth Street in 1900 from Henry Sanford's London-based Florida Land and Colonization Co. to the Trustees of the Odd Fellows Cemetery. The trustees were Frank Harris (shown below), Frank Hall, Prince Strobert, William C. Steward, Wade Watson, and Stephen Guerard. The trustees paid $30 for five-eighths of an acre. The cemetery is often mistakenly called the Page Jackson Cemetery. William Page Jackson farmed 5 acres near the cemetery, and along with Stephen Guerard, dug graves at the cemetery. Legend says Jackson often waved to people visiting the cemetery, so they started calling it the Page Jackson Cemetery. With others, the name was more of a threat, as in "I'm going to send you to Page Jackson." Guerard, who also worked for the railroad, farmed his land behind the nearby Evergreen Cemetery. Sanford's Airport Boulevard through the area at State Road 46 was once called Grapeville Road. Families walked from Georgetown to the cemetery to clean around the gravesites. Children would run ahead, stopping off at the Black's home at Twenty-fifth Street and Sanford Avenue to pick grapes from their arbor.

Shown here seated is Elizabeth Jackson, Page Jackson's wife. The other family members have not been identified.

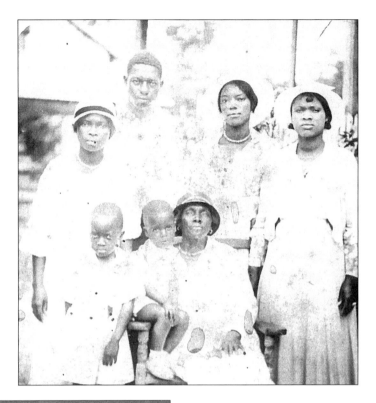

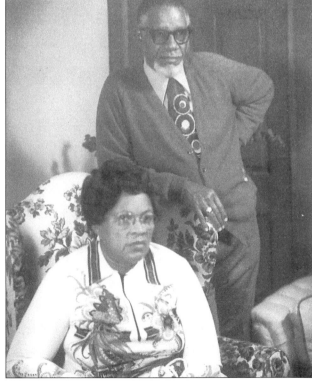

Page and Elizabeth Jackson's daughter Vivian married James Walden Sr., one of the sons of Albert Walden, mayor of Goldsboro. Two of their sons, James Walden Jr. and Truby Walden, still live on the family property near the Evergreen Cemetery.

The Good Samaritan Home was founded by "Mother" Ruby Lee Wilson, shown here accepting one of the many honors city officials awarded during her lifetime. The home has provided food, shelter, and loving care to the poor, homeless, and aging, white and black, since 1948. The center is at Eighth Street and Mulberry Avenue in Goldsboro.

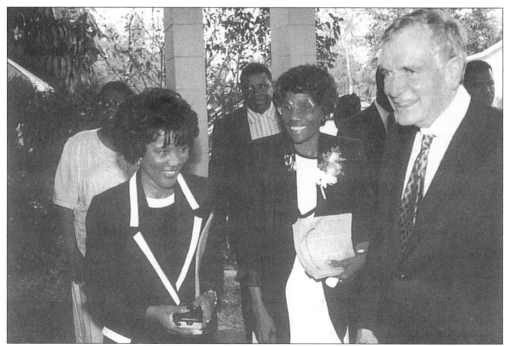

The Good Samaritan Home is now run by Mother and Timothy Wilson's daughter, Thelma Mike, shown here with one of the home's political supporters, the late Gov. Lawton Chiles, and Mike's daughter, Victonia Murphy, administrator at the home.

This is an Easter egg hunt at the Rest Haven day nursery and child-care center run by Mother Wilson for working mothers. The center has also been used as a shelter for orphaned and homeless children.

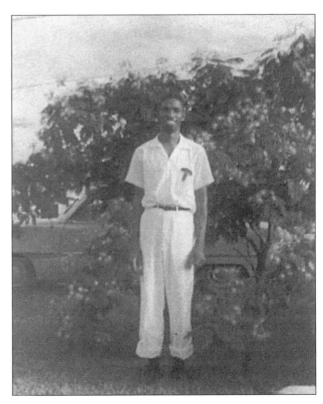

Hezekiah Ross, shown here outside the Good Samaritan Home, was one of the first aides to work with Mother Wilson.

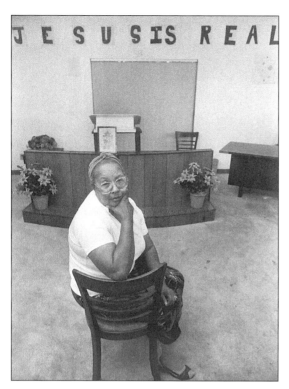

Mother Blanche Bell Weaver is shown inside the chapel of the Rescue Outreach Mission on West Thirteenth Street in Goldsboro (left) and surrounded by some of the many children who have come under her care (below). She is the founder and director of the mission, which helps the poor and homeless in Seminole County. She offers a hot meal to anyone and gives away donated clothing and boxes of food. Since 1987, the mission has been the only homeless shelter in Seminole County. Mother Weaver opened a shelter for men, then added a shelter for battered women. When other agencies provided for battered women, Mother Weaver opened that shelter to homeless women.

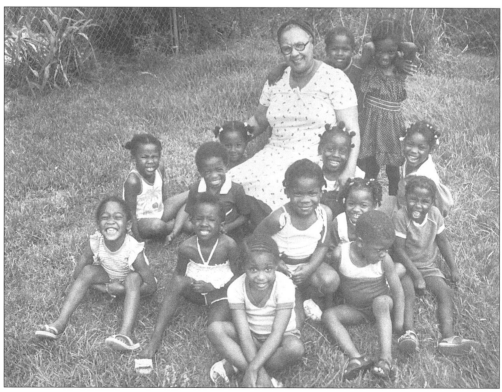

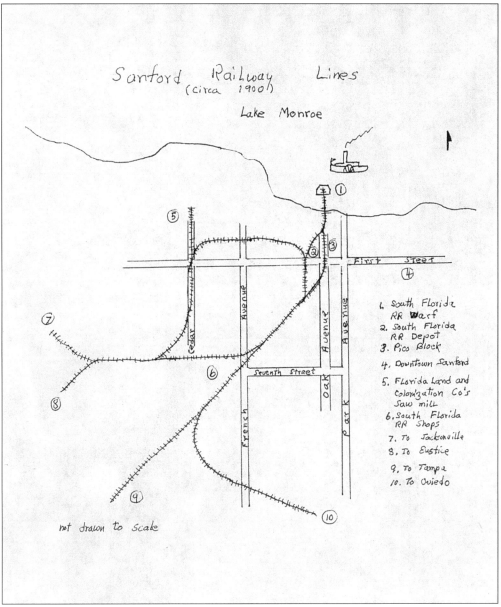

This hand-drawn map from about 1900 shows the railroad routes from the Sanford's lakefront, where steamboat commerce merged with train traffic. The South Florida Railroad wharf was at the foot of Oak Avenue along Lake Monroe. The railroad's depot and its hotel, which survives today as professional offices, were opposite each other on Oak Avenue. The name of the hotel was PICO Hotel, which stood for the Plant Investment Co., and was owned by Henry Plant, whose grand Tampa Bay Hotel was built in the same style. Tracks reached to Henry Sanford's Florida Land and Colonization Co.'s sawmill (west of town) and the railroad shops at Goldsboro's Seventh Street and French Avenue. The railyard included a locomotive roundtable, a railroad car manufacturing shop, and steam engine repair shop. Tracks led from Sanford for Jacksonville, Eustis, Tampa, and Oviedo. At least 25 trains a day left Sanford in 1900.

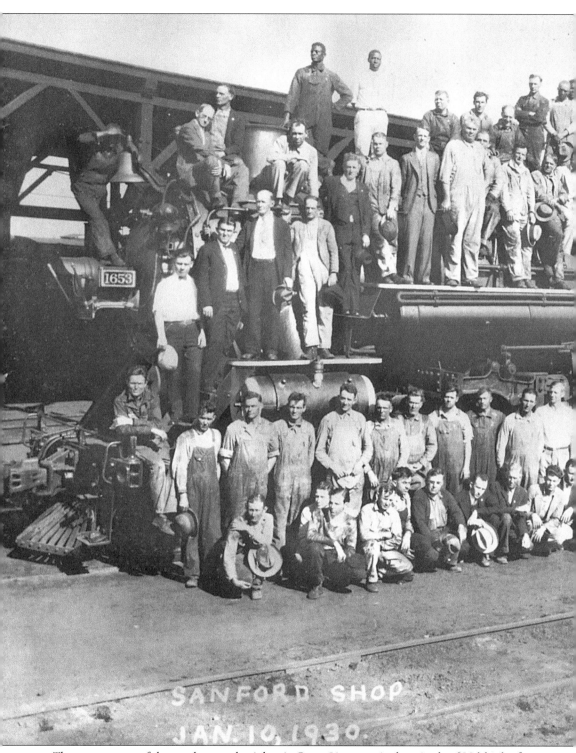
These are some of the workers at the Atlantic Coast Line repair shop in the 600 block of west

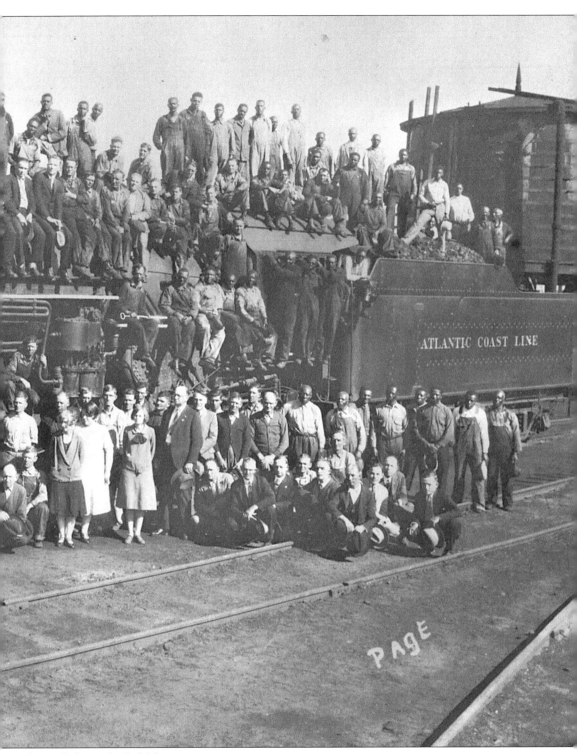
Seventh Street in Goldsboro.

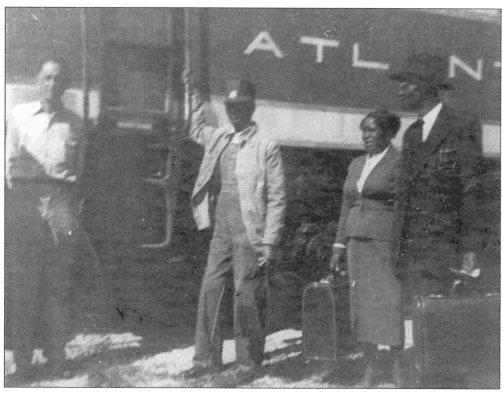

A.A. Fields, the fireman in the center, welcomes A.C. and Lizzie Lamb as they board the train for their first vacation after his retirement from the railroad. The Lambs lived at this house at Thirteenth Street and Southwest Road in Goldsboro.

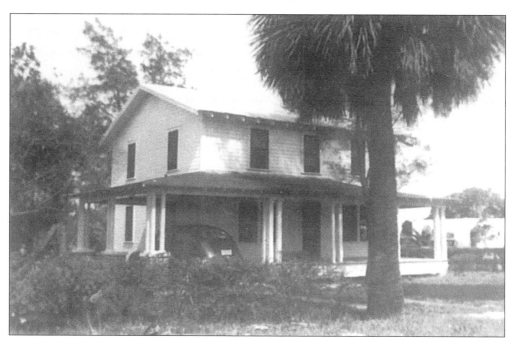

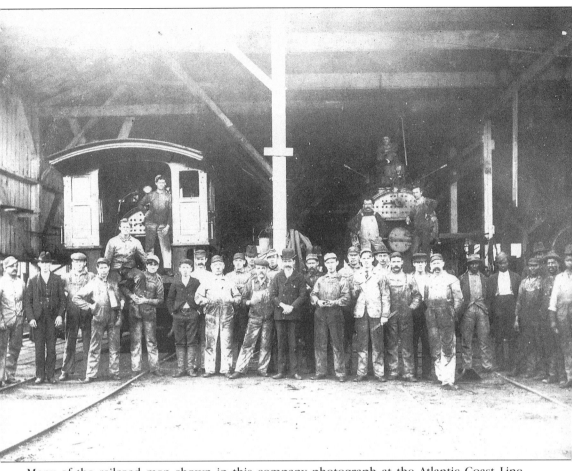

Many of the railroad men shown in this company photograph at the Atlantic Coast Line roundhouse in 1930 came from Goldsboro and Sanford's other black neighborhoods. Goldsboro and other Sanford communities began when Freedmen's Bureau agent Walter Gwynn recruited many black workers to settle in the pioneer towns and build railroads. Putting down tracks provided jobs for hundreds of black laborers throughout the late 1800s as railroads stretched to both coasts of the state and Key West. The 1880 census included 360 black laborers in two railroad camps near Sanford. One was identified as a surveyor who had come to Florida with the railroad planners. Railcars for the South Florida Railroad were built in shops in Goldsboro. Goldsboro residents found jobs at warehouses and repair shops, the loading docks, a rail hospital at the end of the rail lines on Lake Monroe, and many other rail-related businesses, such as restaurants and hotels, lunch rooms, clothes cleaning establishments, and pool rooms.

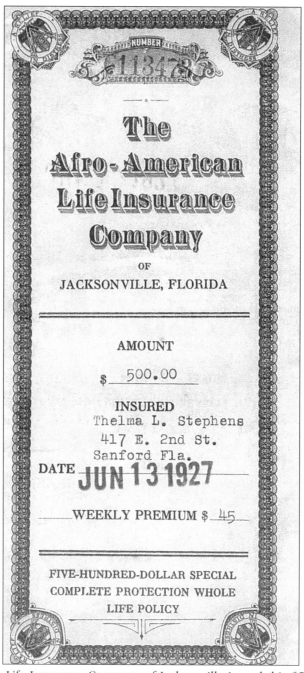

The Afro-American Life Insurance Company of Jacksonville issued this $500 life insurance policy in June 1927 to a Sanford woman. The weekly premium was 45¢. The policy was discovered in the early 1990s when the county was demolishing old houses in Lockhart. Another policy shows that the owner was 34 when she begin making payments of 10¢ a week on a $120 life insurance policy. The policy was issued December 5, 1938. The same woman took out a another policy at the same time, paying 25¢ a week. This policy paid $60 if she died and $5 a week if she was injured.

The housing in Goldsboro also reflects the community's early concentration of farming and rail workers. These houses along West Tenth Street and the cluster communities like Bailey's Corner were home to black laborers.

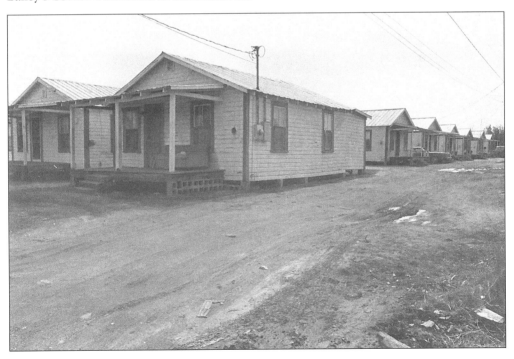

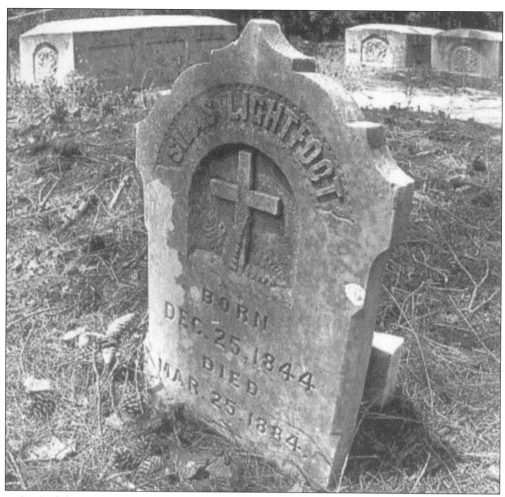

A third of the Union troops at the Battle of Olustee, Florida's bloodiest fight, were black. Some of the survivors stayed or returned to Florida after the war. At least three Union Army veterans recruited for black units are buried in Sanford and Forest City cemeteries. This gravestone of Union private Silas Lightfoot is under a tall pine in recently cleared Section 1 of the grounds city records called the Combined Colored Cemetery. Nearby is the unmarked grave of another African-American veteran of the war, Sandy Cary. Their graves are in the closest section south of the Lakeview Cemetery off West Twenty-fifth Street. Both their names and that of a third black Union soldier named John Campbell, who is buried in Forest City, appear on the African-American Civil War Memorial in Washington. Lightfoot enlisted at Arlington, VA, and served at St. Marks and Tampa, mustering out in January 1866. Lightfoot and his wife, Hattie, and their children are in Georgetown church records. Also, the family is thought to have operated a store next to their home on Cypress Avenue. Lightfoot died March 25, 1884. Cary served as a private in a Union company organized in South Carolina. His unit was assigned to duty in Jacksonville, Palatka, and the former St. Johns River town of Picolata. A St. Johns expedition in 1864 brought the solders to Enterprise on Lake Monroe, possibly patrolling for blockade runners trying to slip by Union ships to land cattle, supplies, and arms. He mustered out in Jacksonville in February 1866. Little is known about Pvt. John Campbell because he is listed with more than a dozen men with the same name on the National Park Service rolls of African-American soldiers.

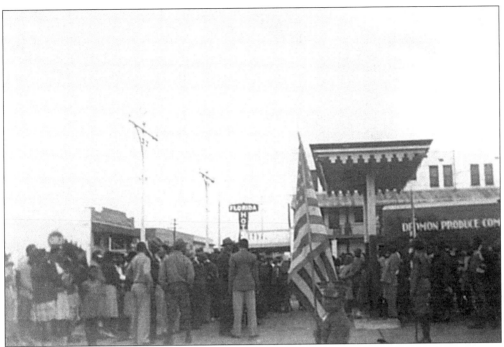

These two World War II-era photographs, one taken December 1, 1942, showing a young boy in uniform holding an American flag, and the second taken October 12, 1942, showing preparations for parade before a railroad send-off, were taken at the same downtown Sanford site. The gatherings were convened as Seminole County's favorite sons were preparing to join other Floridians who fought during World War II. The photograph was taken at Third Street and Park Avenue, looking north. A Sinclair station is the foreground and Florida Hotel is visible in the back.

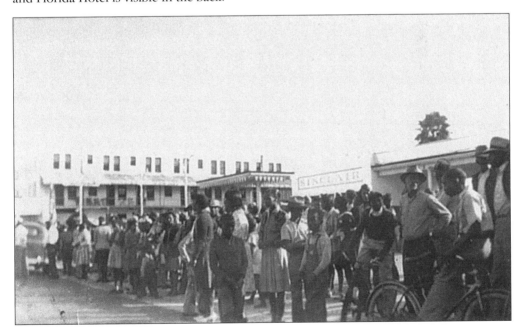

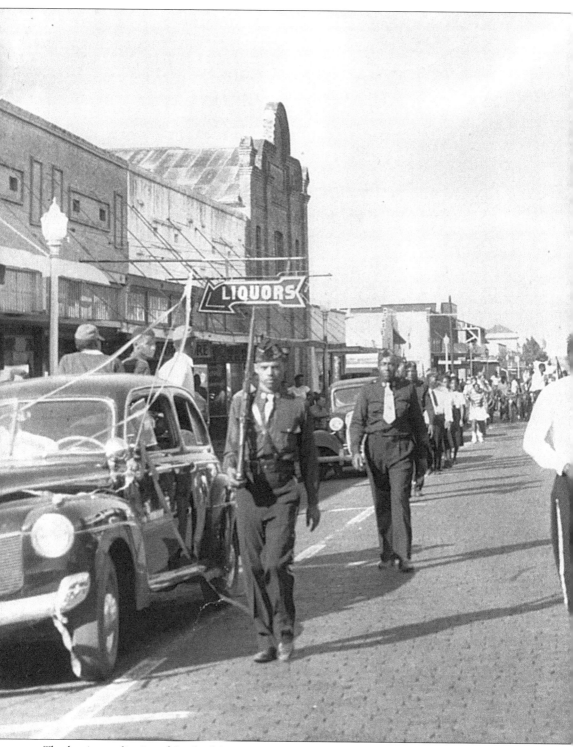
The business district of Sanford Avenue was used for a military parade at the end of World

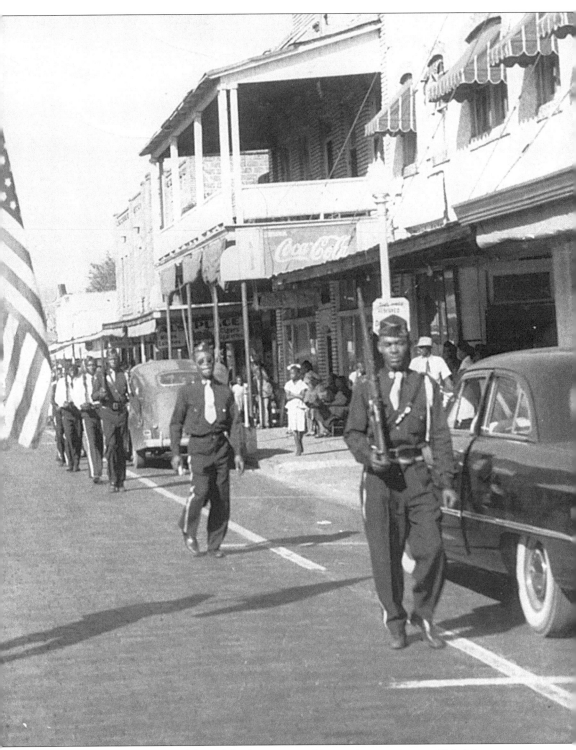

War II to honor returning soldiers. The honor guard is moving south near Third Avenue.

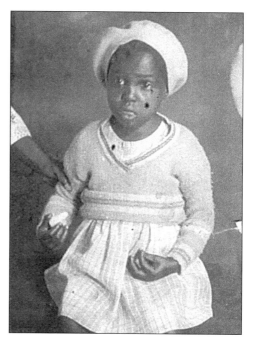

Willie Agnes Riggins Knighton, shown as a little girl in the top right picture on the previous page, still lives at the family home at 1120 Cypress Avenue. She is also shown in the top left picture with her twin brother, Joseph Edward Riggins. Her parents were Joe Riggins and Willie Wilkins Riggins. Her two older sisters, shown on the bottom of the previous page with their mother in the middle, are Louise Wilkins Blair (left) and Leola Wilkins Bryant. The three grown sisters are also shown above. Their father left when the twins were two years old, but "mother never gave up hope . . . She had to work, and we had to be obedient to everyone and show respect. We weren't allowed outside after six o'clock." She thought her mother was too strict. "I didn't realize it then, but I can appreciate it now . . . My mother was not an educator, but she saw to it that we all finished school. We were brought up in a religious home. We had family prayer around the bed. We had to attend church and go to school. We had to respect our older sisters because my mother had to work. She did celery field work, house cleaning, and office cleaning at a lawyer's offices. She didn't leave us at home with our sisters. She would take us with her when she did office work and house work . . . Sometimes we would pull weeds out of the grass or flowers beds where she could see us. Mother took in washing and ironing, which we had to do, also. We all had our own ironing board and washing board. I still have mine. When she would buy our clothes, we would always have clothes for Sunday and clothes for school. She always bought us two pairs of shoes, one for school and one for church. We attended Zion Hope M.B. Church at an early age because Louise and Leola were very active in church, and they would take us to Sunday School with them. My brother and I attended Hopper Academy, Crooms Academy, and I also attended Hungerford High School in Eatonville, which I graduated from, and went to Bethune-Cookman College. I was there when Mrs. Mary McLeod Bethune passed in 1955. All of us finished college." Her sisters went to Bethune-Cookman, too. "I graduated in 1956. My twin attended Florida A&M University. I was able to get my first job as a teacher at Hopper Academy, which was an honor to me because I attended there. The next year they built Hopper Elementary, where I taught until integration, when I was transferred to Sanford Grammar. After a number of years they consolidated three schools and built Hamilton Elementary School in 1984, where I worked until 1991. I retired after 33 years. I am now married to Oscar Knighton. I owe my success to my parents and having faith in God. I have been a church worker and a community worker all my life." She volunteered for 22 years at Central Florida Regional Hospital. "I thank God and my mother and sisters for keeping a tight line on my brother and me."

The politics of other places brought some people to Sanford. Annie Hamiter, shown here with her husband, Jack Hamiter, came to Sanford in late 1920 after the violence in Ocoee. Two whites and at least five blacks were killed in November 1920 in rioting that followed a dispute when a black man tried to vote. Twenty-five homes, two churches, and a Masonic lodge in the black community of Ocoee were destroyed. After raising three children, she trained at the Florida Normal Institute in St. Augustine to become a midwife and helped organized the Christian Missionary Society at First Shiloh Missionary Baptist Church.

Bill Roundtree was a long-time worker for the Terwilliger's Miracle Concrete Co.

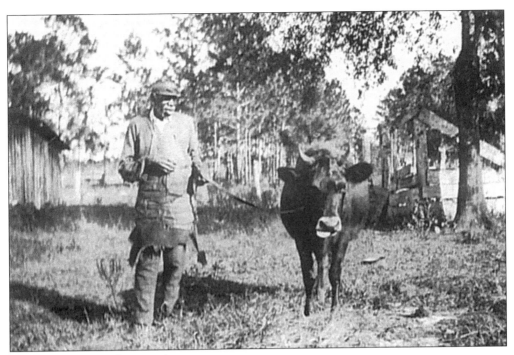

This Cameron City farm worker identified only as "Lam" holds a leather leash as he walks along with a lone member of the farm's cattle herd. Lam also is shown at right holding a cane outside a farmhouse with a woman identified only as Ellie.

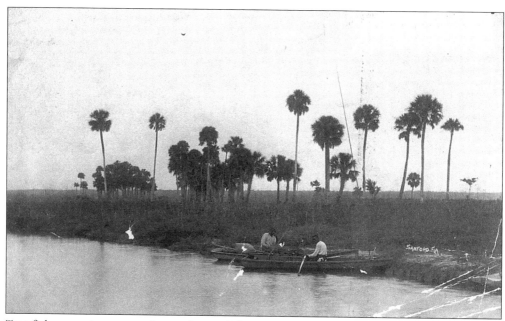

Two fishermen in separate boats chat on Lake Monroe. They appear to have been fishing for pleasure or that night's meal, but commercial fishing was once a major enterprise along the river and the lakefront at Sanford.

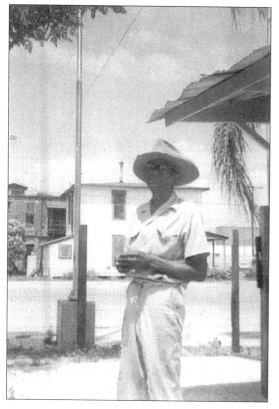

Luke Wright was a Sanford area artist, wood carver, cattleman, and rodeo performer who traveled throughout the state. He is the uncle of James Wright Sr. and Dr. Stephen Caldwell Wright of Seminole Community College.

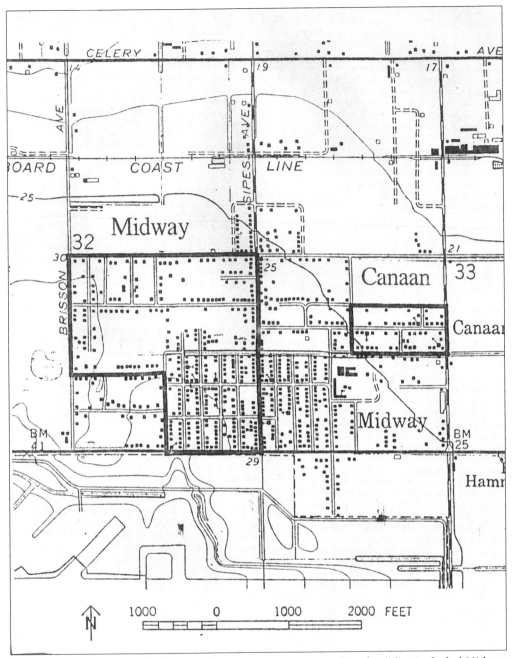

This county map shows the farm-worker communities east of Sanford that included Midway and Canaan.

These Midway kids with their homemade wagons show how much enterprise they had to make do in the farm town east of Sanford. They fashioned their wagons from old wheels and vegetable-packing crates.

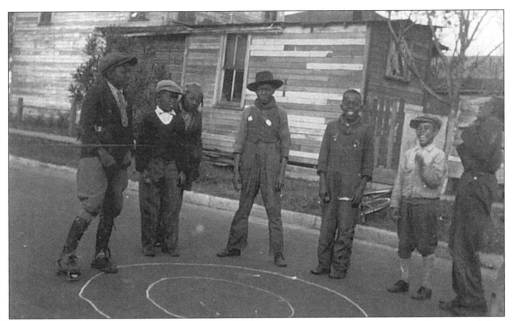

They lived in poverty, but they found plenty of opportunities to have fun playing marbles. These children are from the families who worked at the Chase farms east of Sanford.

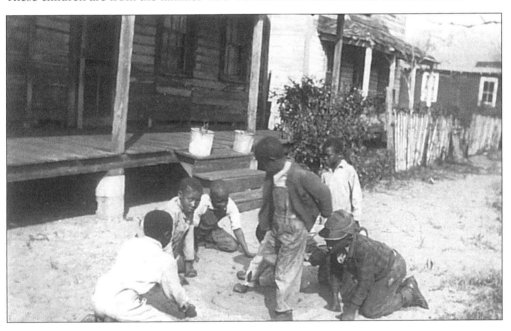

The Ensminger Brothers Photographers of Sanford sold many photographs of the children from the farm workers who lived in the Midway and Canaan neighborhoods and worked at the nearby farms. In this picture, three boys and two girls pose on the porch of a family home in Midway.

This Ensminger Brothers photo shows a Midway girl sitting outdoors and eating peanuts.

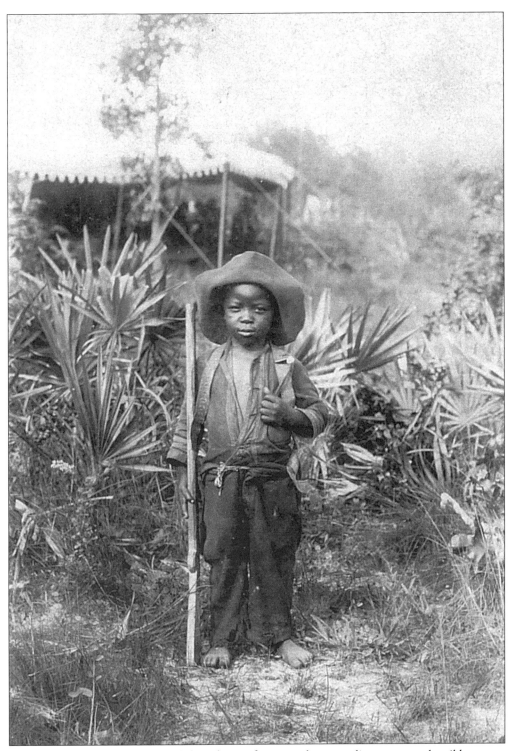
The Ensminger Brothers named this photo of a young boy standing on a sand trail between scrub palmetto plants and holding a wooden toy rifle: "On Guard."

"All in a Row" is the name the Ensminger Brothers picked for this Canaan porch scene of five girls posing in Sunday or school clothes.

The Ensminger Brothers' peanut girl is joined by other family members and friends for this group photo in Midway.

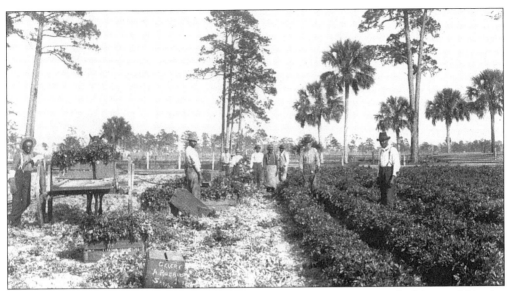

These men are working in the celery fields east of Sanford, celery capital of the world in the early 1900s. Oranges had been the major crop along the upper St. Johns until the killer freezes of the winters of 1894 and 1895 bankrupted many grove owners. Many settlers left the area to find work. Some growers replanted, but most of those who stayed turned to vegetable farming. Celery became king.

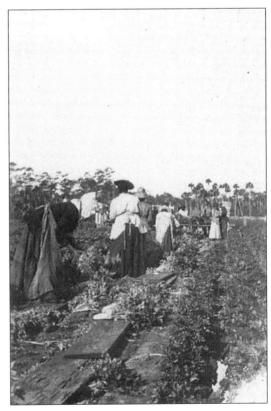

Women worked in the fields, as well as the children. Some attended "celery schools," like the strawberry schools of Polk and Hillsborough Counties. These rural schools were in session from May through August. This allowed students to work when the need for their labor was the most productive. Some people, including newspapers, condemned the summer scheduling as an excuse for child labor. Millie Morgan, a graduate of Shaw University, taught the Midway students until a formal school was built. The community school opened with a principal, S.E. Moore, and had two teachers, Maude Clarke and Fannie Reid. The school had 327 students and 9 teachers by 1936. After the ninth grade, Midways students attended Crooms Academy in Goldsboro. A fire burned the first schoolhouse. A new one with six classrooms opened in 1938. Midway and Canaan were along the line served by the Sanford Traction Co.'s trolley, which was started by celery growers.

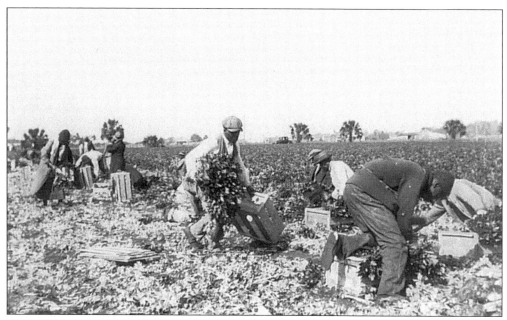

These Midway men are harvesting celery. Farmers harnessed the artesian wells around Sanford and developed underground irrigation systems that grew the region's world-class celery crops. Midway started as a halfway rest stop for horses pulling wagons carrying celery workers between the fields and their houses in Sanford. Growing celery provided year-round work, allowing families to build the first houses at Midway and Canaan between Celery Avenue and Cameron City. Midway had its own school for students until they were old enough to attend Crooms Academy in Sanford.

These workers harvest celery with a farmhouse in the background. An account written during the Great Depression for the Federal Writers' Projects included this passage about the farm workers at Midway and the advantage they had because they could walk to the celery fields: "The laborers in and around Sanford are transported to and from the fields in huge trucks, with slatted sides and so many Negroes in each truck that they stand wedged in literally like sardines in a can."

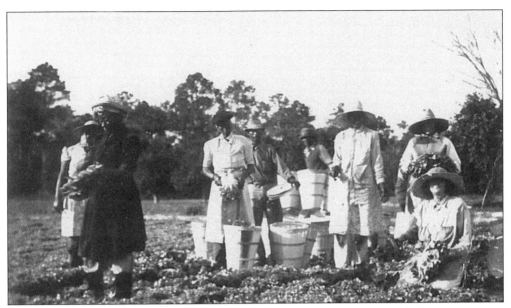

These women working in the celery fields wear hats and long-sleeve clothing to protect themselves from the sun. About half way between downtown Sanford and Cameron City, at least eight farm families lived in the Midway/Canaan area in the early 1900s. St. Matthew Missionary Baptist Church, formed in 1910, was built in 1916 in Canaan. That same year, some St. Matthew members started the Progress Missionary Baptist Church in Midway. New Bethel African Methodist Episcopal Church in Canaan formed about 1911 and held their first meeting in a barn at R.H. Muirhead's celery farm.

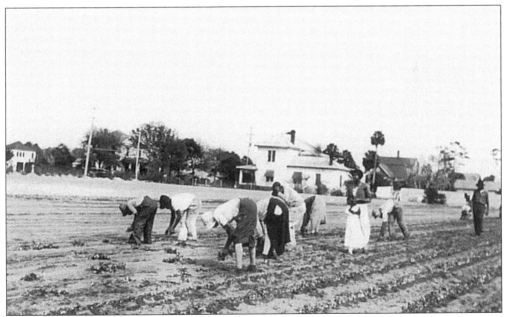

This is a scene of farm workers planting celery with a farmhouse in background. During the boom days of the late 1920s and early 1930s, Midway's population grew at a steady pace as the area celery farms hired more workers.

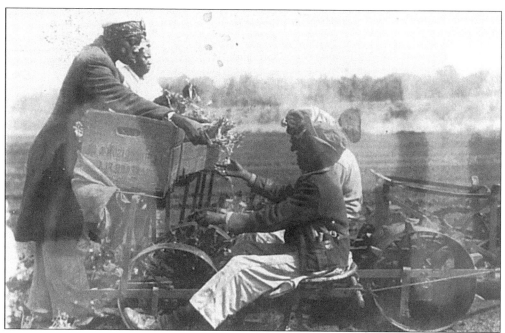

Farmers used several varieties of machines and vehicles to plant celery. The Sanford-area farm workers proved their value when farmers from California, during a lettuce strike, "sneaked in under cover of night and carried off two truck loads of our hands," according to the account in the records of the Federal Writers' Projects. "The county went wild, you would have thought that they were without fault and were lumps of pure gold . . . Of course, I don't claim that our Negroes are faultless, but I do claim that they are better than average. I believe that they prefer good citizenship to bad, and the plowshare to the pistol and razor," wrote Margaret Barnes in the 1930s for the Federal Writers' Projects.

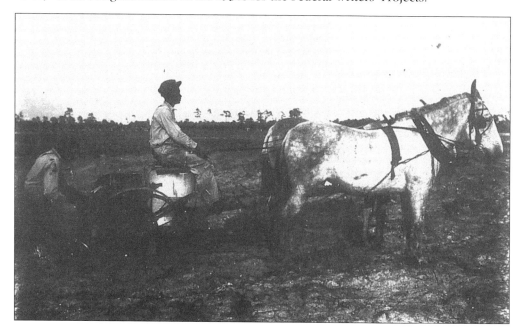

Earl Williams of Midway was the second president of the Seminole County chapter of the NAACP. Arthur James was the first president.

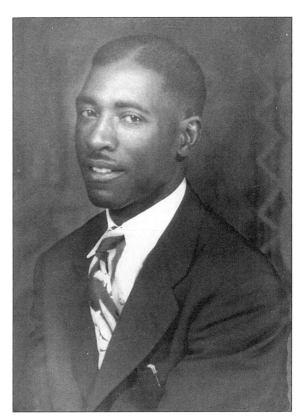

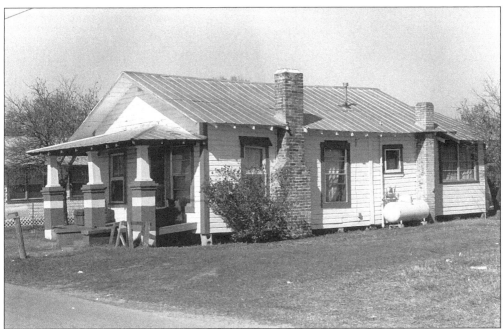

This Midway house at 3391 Main Street is typical of the houses built in Midway during the early 1900s.

This is the former Bookertown School, now used as a community center. The community was organized and had its own school in the late 1800s. David Henry Clay Rabun helped established the new school for 18 students in the 1920s. Some of the school's students could have found enlightenment by studying the street names in the community, once part of Henry Sanford's Florida Land and Colonization Co. The community traces its beginning to those who tended to the celery field of Sanford's westside, but its streets are named to honor the likes of poet Paul Lawrence Dunbar, early civil rights activist W.E.B. Dubois, African Methodist Episcopal Church founder Richard Allen, and journalist, orator, and anti-slavery activist Frederick Douglass. Bookertown is near the huge ice plant at the railroad freight yard at the community of Lake Monroe. It served the area's truck farms during the early 1900s, when Sanford was known as "Celery City." The Rand Yard ice plant supplied refrigerator-car trains that served the truck farms. At its peak in 1923–1924, 8,363 rail cars of lettuce, oranges, grapefruit, cabbage, peppers, and other vegetables, including 5,822 cars of celery, were shipped out of the Rand Yard.

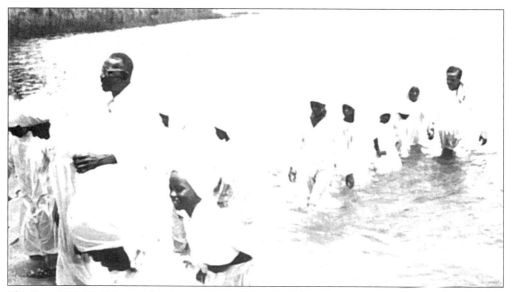

The Rev. S.W. Washington leads members of the Providence Missionary Baptist Church after a baptism in Lake Monroe at the end of vacation Bible school in 1965. The church was founded by residents of Bookertown in 1918.

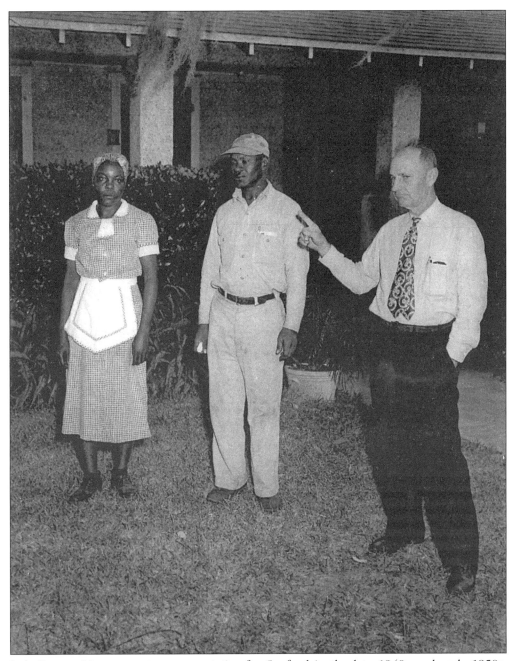

Luis Bartow Mann, a state representative for Sanford in the late 1940s and early 1950s, planned and surveyed lots for home sites in Bookertown for workers at his farm nearby. Mann is shown here making his annual awards for his best employees, Dora Keitt and Walter Griffin, at a 1951 picnic.

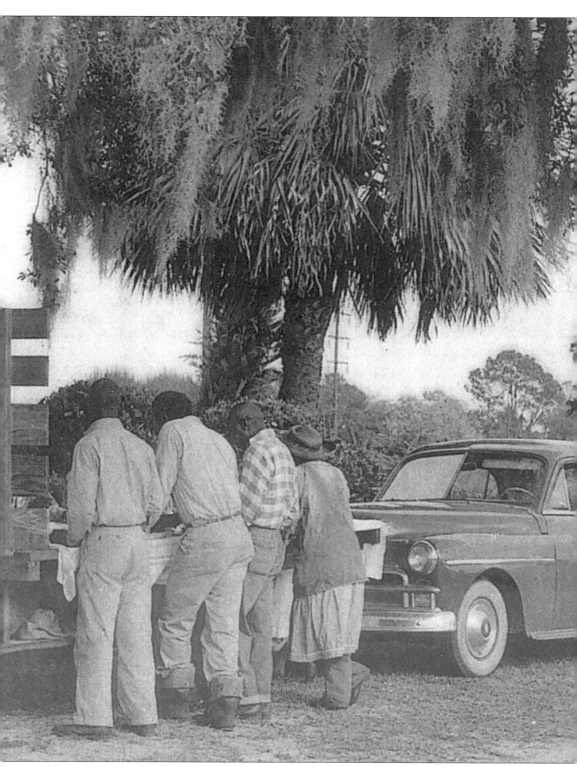
Two flatbed trucks were used as the tables for the annual picnic for the workers at the L.B.

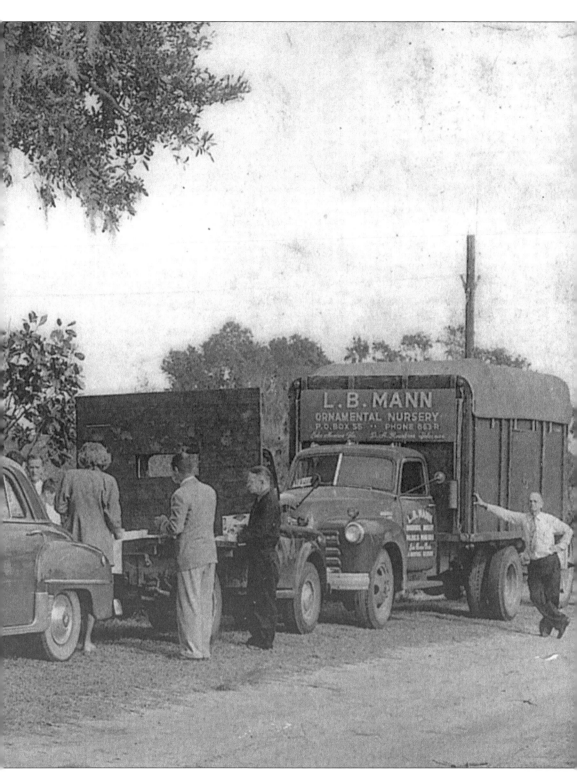
Mann Ornamental Nursery near Bookertown.

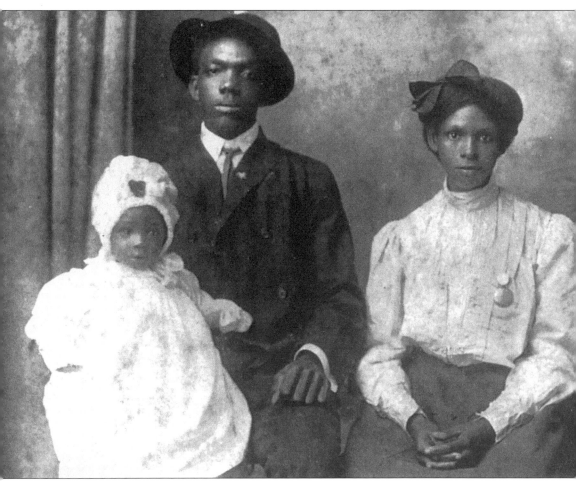

Lovette Thomas, shown here with his wife, Gussie Mae Thomas, and their daughter Ella, raised his family at Markham, which began more than 120 years ago as a remote lumber and turpentine community in the pine flatlands near the Wekiva River. Another daughter, Maybelle Thomas Glover, said Markham was a company town, but her father was a farmer and deacon at the Oak Grove Missionary Baptist Church. The Pinnie Ridge Cemetery, also called the Piney Woods Cemetery, was next to the church. Her father built their farm home. They grew cabbage, string beans, potatoes, onions, mustards, collards, corn, and okra. Sometimes twice a week, her father hitched his horse to a buggy to haul produce to Sanford's markets and returned with groceries, clothing, and supplies. As a child, she walked from her father's farm to the church's school, where the schoolteachers had 50 students.

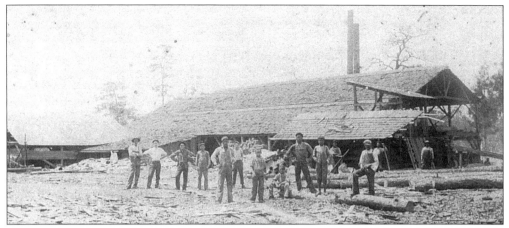

This is Bothney Sawmill, one of the many sawmills that kept busy during the late 1800s and early 1900s when logging was a major enterprise in the Twin Lakes and Markham areas. In 1875, William Markham bought land thick with pines. Lumbering, sawmills, and turpentine stills provided work for black settlers. Florida's forests yielded profits for the mostly out-of-state companies that owned the timber and turpentine rights. The companies, though, kept the men who worked the trees in poverty. Crews, and sometimes their families, were crowded into isolated shanties. The food and wages were miserable. Many were forced to trade the scrip they earned for overpriced goods at company stores.

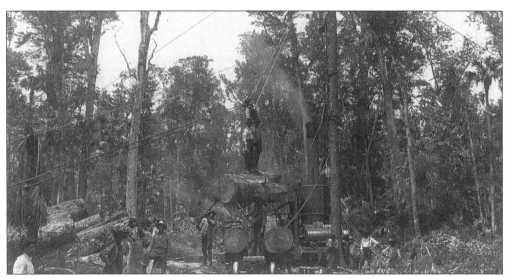

Logging crews, such as this one hauling timber on overhead lines and pulleys to the Wekiva River, worked throughout the river basin near Markham. Companies provided common buildings for a church, school, and social hall, but living conditions were primitive. The Florida Parks Service in 1996 dedicated a historic marker just east of the sharp bend where Longwood-Markham Road becomes Markham Road. The marker, located near the community's cemetery, honors the industrious Markham people. "They built railroads, produced lumber and turpentine, grew citrus and worked the land. Markham and its surrounding area attracted not only a labor pool but also permanent settlers who built homes and bought and farmed their own land . . . They worked hard, educated their children, and survived many hardships with dignity."

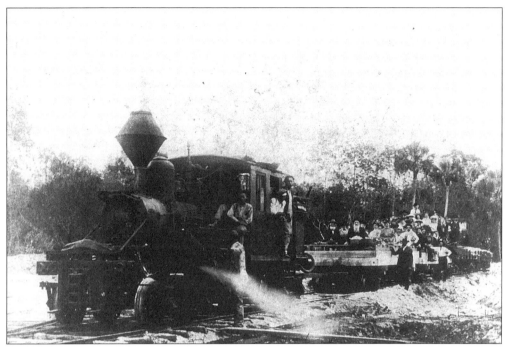

Employees of Consumers Lumber and Veneer Co., which logged in the Wekiva River area, used the company's log train and flatcar to get to a picnic in 1908 at Rock Springs.

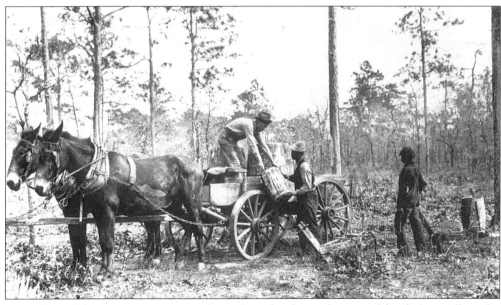

Sap collected from pines was poured into barrels, shown here, and hauled to stills to be cooked to make turpentine. "Men would chip bark, collect the sap in clay cups, transfer it to wooden barrels and take it by mule and wagon to Mr. Hagan's distillery and later to 'The Section' (the Markham train station)," said Maybelle Thomas Glover, who was born in Markham in 1912. "There was a commissary and little houses for the workers there near the train station."

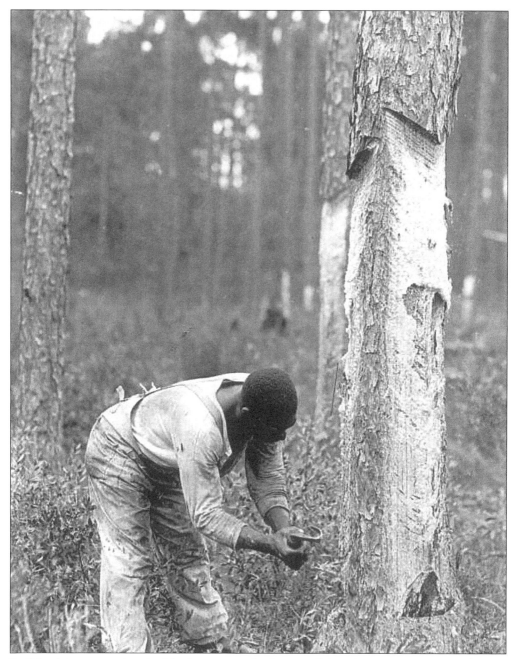
In this picture a worker is chipping away a fresh area of the pine to mount a container to collect sap.

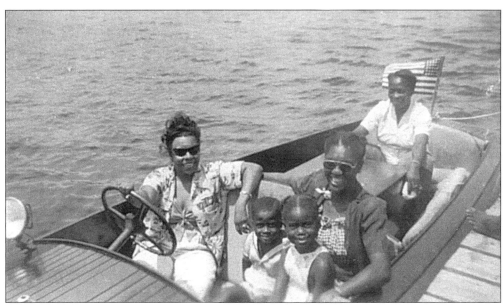
The Foster and Wright families enjoy a day of boating in the mid-1940s while visiting the Scouts at Camp Lincoln near Markham.

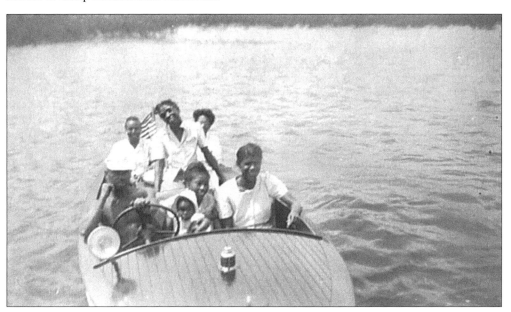

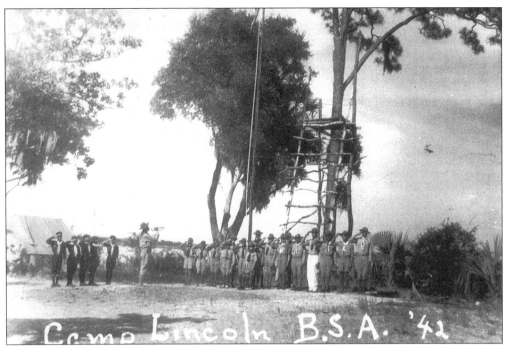

Near the Markham and Sylvan Lake communities was Camp Lincoln, pictured here, opening in the 1940s for black Boy Scouts. This photo shows the Scouts raising the flag during a morning ceremony in 1941.

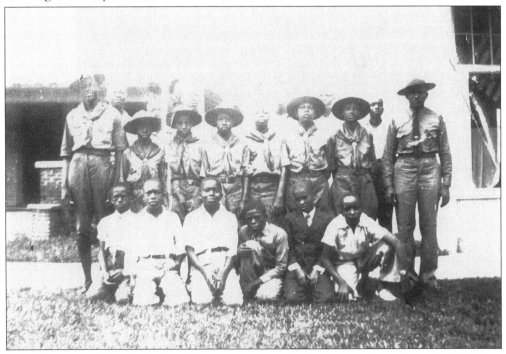

Boys from one of Sanford's Boy Scout troops pose before a camping trip to the Markham Scout grounds at Camp Lincoln.

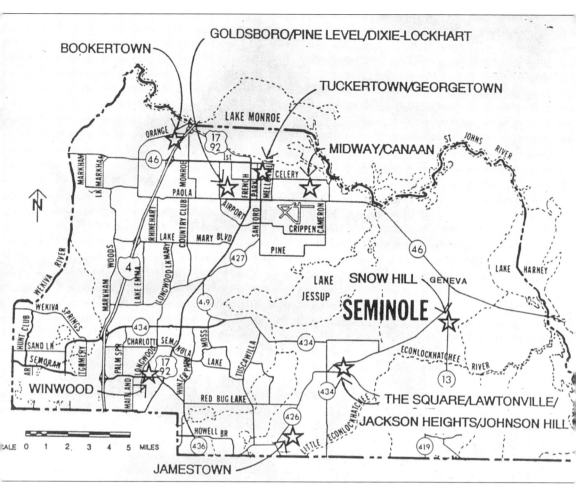

This Seminole County map shows the historic black communities of Seminole County. Most are concentrated in the north end of the county, but in each case, the first black communities were founded near the major agricultural centers of the late 1800s and early 1900s. Sanford's communities were part of the region's citrus groves, celery farms, and packinghouses. The east side of the county along the St. Johns and Econlockhatchee Rivers as well as the western border along the Wekiva River were home to hundreds of logging and turpentine camps. The Longwood, Altamonte, and Casselberry communities at the southern end of the county had citrus groves and timber and sawmill operations, but many of the jobs were at the ferneries. Logging, turpentine and citrus are provided employment in the Oviedo area communities, but the celery grown there rivals Sanford.

# Two
# OVIEDO AREA COMMUNITIES

Lawtonville, north of Broadway and several other Oviedo area communities, provided the homes for farm workers who created Oviedo's early prosperity as a leading agriculture center. The Square, or Washington Square, is west and north of Lawtonville. Boston Hill is south of Oviedo. The Scrub is west of Oviedo near the high school. Johnson Heights or Washington Heights is northeast of Lawtonville toward Geneva and Snow Hill. From these neighborhoods came the people who cleared off pines and make lumber at sawmills. They dug up the scrub and planted and tended the orange groves. They picked and packed citrus for shipping. They built the railroads and worked the turpentine farms and the celery fields while packinghouses provided domestic labor. Geneva includes the former site of the cypress mill town. Some of Oviedo's first black families came to the area in the late 1860s to work at the orange groves at the Lake Jesup settlement and Lawtonville at Lake Charm. Martin, Sarah, and Malinda Powell, as well as Malinda's sister and mother, reached Oviedo with the family of Baptist reverend George C. and Patience Powell. George Powell began buying land in the area in 1867 after moving his family from Live Oak when news spread that his son Lewis was the Florida soldier hanged as one of the conspirators in the assassination of Abraham Lincoln. Orange County's voter registration roll listed Martin Powell as a grove owner in 1876. Malinda Powell's sister Mary married Lewis Jones. They were known in the community as Mammy and Grandpa Jones. She was a nurse and midwife, helping hundreds of mothers deliver babies in Oviedo, Jamestown, and Snow Hill.

This postcard shows how Oviedo's Broadway looked in the late 1800s and early 1900s.

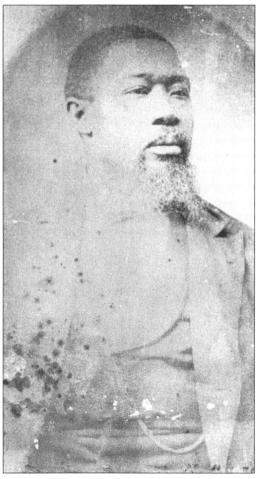

Oviedo pioneer families in April 1875 formed the Antioch Missionary Baptist Church, shown above as it appears today. The first pastor was The Rev. Amos Laster (left). Martin Powell was one of the founders, and one of early ministers was The Rev. John Hurston, father of folklorist and anthropologist Zora Neale Hurston. The first sanctuary was a small log cabin, replaced in 1880 with a box-like building and later a new church with a belfry and a bell in 1889. The churchyard off East Broadway Street included a cemetery. The sexton's duties included ringing the bell for services as well as to announce when a member died. A lodge hall and schoolhouse were built across the street. When the First South Florida Association was organized, Antioch was one of the churches to join. Among its growing membership came the organizers of Fountain Head Missionary Baptist Church in 1923. Antioch's annual picnics were held along Lake Jesup at White's Wharf. Antioch is one of the oldest in historic Orange County. The last major changes were in the early 1940s, but repairs were made after the sanctuary was moved during the widening of State Road 419 in 1948. Before the baptismal pool was built, the membership walked more than one mile to Round Lake for baptisms.

THE OVIEDO CHRONICLE - FRIDAY, OCTOBER 25, 1889

- - - - - - -

## A NOVEL MARRIAGE CEREMONY

- - - - - - -

A marriage ceremony took place at the Colored Baptist Church on Wednesday night that was conducted in an entirely original manner, and totally different from the conventional forms now adopted by society. The high contracting parties were among the leaders of the colored social world of Oviedo, and their marriage announcement caused a large number of ladies and gentlemen to honor the occasion with their presence, and to say that these fell highly repaid is conveying but a slight idea of the true feelings of the witnesses to this very interesting ceremony.

When our reporter reached the colored church with a large party of ladies and gentlemen, an earnest prayer meeting was in progress, which was led by one of the young men of the congregation. At 8 o'clock, the Rev. Amos Laster, pastor, took his stand in the pulpit and commenced a discourse, apparently oblivious to any unusual occurrence to take place.

He was just warming up to his subject, when the doors of the church opened, and a procession of three couples marched up the center aisle. The first two couples were John Collins with Miss Anna Payton, and Anderson Colyer with Miss Carrie McCarthy, bridesmaids and groomsmen, and the third couple were the bride and groom, Miss Lula Miller and Chas. F. Collins. The latter couple proceeded to the front of the altar, when they were seemingly noticed for the first time by the pastor, who closed his discourse with the remark that he would "change the subject," as there appeared to be a couple who wanted him to marry them.

The ceremony that followed will never be forgotten by the white people present and could only be fully appreciated by hearing it repeated.

The Rev. Amos commenced with stating that it was not well for man to dwell alone. Then he pictured to the young couple standing before him the dark side of married life, advising them that all would not run smooth. After instructing them to take each other by the right hand he pictured the life of married people and showed how unhappy they could be, and told them that it was not yet too late for them to "cut loose and run home."

But the couple had no inclination to "cut loose," and Rev. Amos gave them such advice, as to the groom to "love his wife in prosperity and 'adventure'" and to the bride to have a "hot dinner and his old breeches mended." He now began the questions to the groom, "will you take this woman, etc." to which the groom answered in a low voice. This did not sait the officiating minister, for in a stern voice he ordered the couple to "look him square in the eye, and speak loud;" no half-hearted business for him.

The ceremony then proceeded smoothly to the close, the pastor getting in a remark after each answer that caused the entire congregation to break out in broad smiles. The ceremony over, the Rev. Laster clapped this unique of all marriage ceremonies by congratulating the groom and bride in turn, and telling the former that he "hoped he would be like Isaac and raise ten boys," and to the latter he closed his congratulatory remarks by hoping she "would be Rebecca and raise ten boys." The ceremony lasted twenty-five minutes. The bride was the recipient of numerous presents from friends in Hawkinsville, Ga. and Oviedo.

The *Oviedo Chronicle* of October 25, 1889, published this account of a marriage performed by Antioch Missionary Baptist Church's reverend Amos Laster.

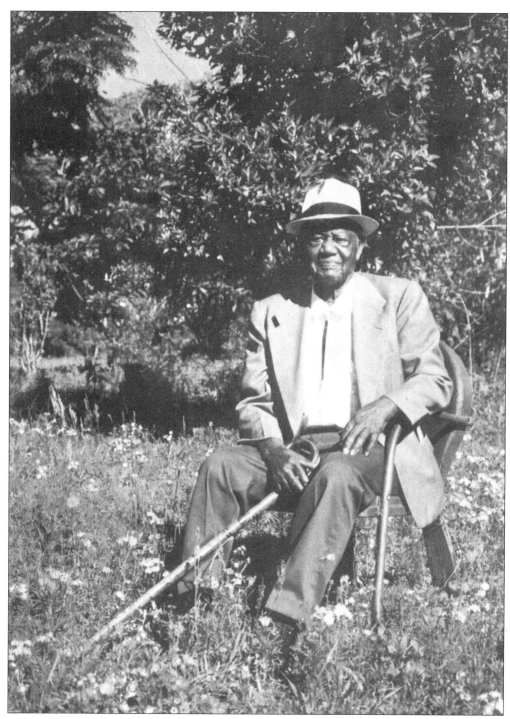

Jackson Heights is south of Lawtonville. It was named for Henry Jackson (above), who came to Oviedo from Thomas County, GA, between 1911 and 1918. He homesteaded at Long Lake. Jackson ran a grubbing crew, starting out with only six men clearing land before working his way to a 16-man crew.

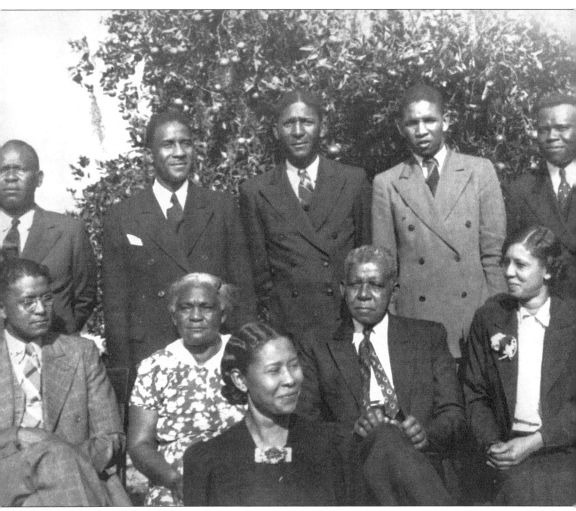

Prince Butler Boston's family came to Oviedo in 1886. Boston, shown here seated second from the right with other family members, joined the Antioch Missionary Baptist Church. He remained a church and civic leader until his death in 1947. He was Sunday school superintendent for 56 years and an ordained deacon for 45 years. During his time, he drew the plans for a new sanctuary, and built the choir stand and two classrooms. The cemetery is on the 5 acres he donated. He served on the school board and the board of trustees of Hungerford School in Eatonville. In his will, he left $1,000 to the church. Boston, a grove owner and nurseryman, is credited with budding the Jamaica Orange in groves of J.H. Lee and others. Boston's fruit became the Temple Orange.

Celery farmer Joe Lee stands with a truck loaded with celery boxes in 1928 at Oviedo, where

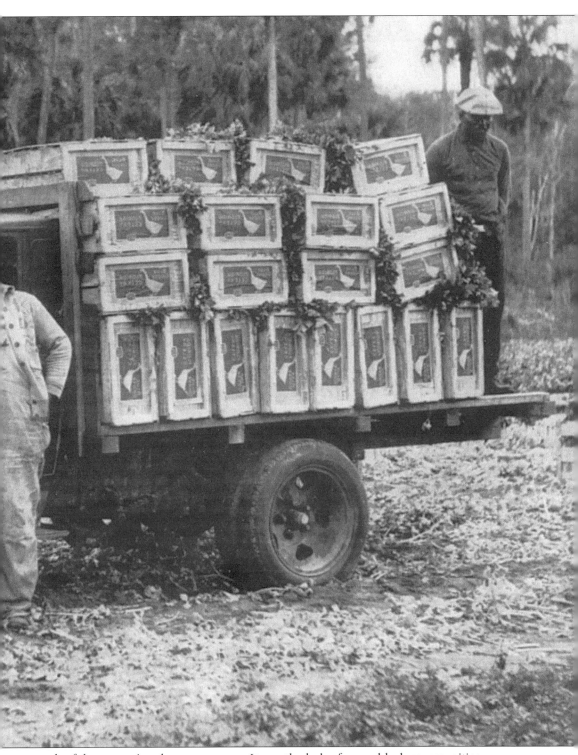
much of the county's celery was grown. It was the hub of many black communities.

Johnnie H. Wright made crates for the Wheeler citrus packinghouse. In the early 1900s, Benjamin Franklin Wheeler joined the partnership of Steen Nelson and Bill Browning at Nelson and Co., which owned Oviedo's leading citrus packinghouse under the brand "Pride of Oviedo." Wheeler later bought out his partners.

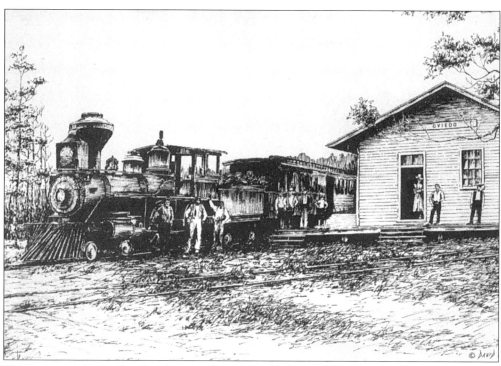

This postcard shows the Oviedo train depot as it looked in the late 1800s and early 1900s.

Stanley T. Muller was principal at Jackson Heights Middle School in the 1960s and the 1970s.

This is Isaac Sapp, a deacon at the Antioch Missionary Baptist Church, which recently celebrated its 125th anniversary.

Jamestown, shown here from State Road 426 in the 1970s, takes its name from Esther and Benjamin James, who came to the area called The Woods in the early 1900s from Savannah, GA. Benjamin James planted an orange grove on part of his 160 acres. He sold some of his land as home sites, beginning in late 1926. Some of the early buyers were refugees from that year's hurricane that struck Miami with winds up to 135 mph, killing nearly 400 people. The first lots were sold to Bob and Flossie Wells, George and Nettie Davis, and Morris J. and Margaret Williams. Williams, who had been a preacher in Georgia and Alabama, raised his family at the turpentine camp at Gabriella near Bear Gully Lake, later moving to farmland off Red Bug Lake Road. He worked at the groves at nearby Bertha and fished and grew his own kitchen garden to feed his family of ten children. He sold some of his vegetables in Maitland and Winter Park, hauling produce to the town markets on Saturdays by a mule-drawn wagon. He later opened the only store in Jamestown. Family members worked at the Duda farms at Slavia as did many of the other Jamestown residents. His children attended the school at Gabriella. In his front yard, he built a brush arbor as the first sanctuary for the Rock Hill Missionary Baptist Church. The congregation later built a church on Red Bug Lake Road on land donated by Dan Nails. When the congregation outgrew that church, the members bought two lots in Jamestown, at the northeast corner of Weston Street and James Drive, and erected a new sanctuary in 1925. St. James African Methodist Episcopal Church began from members of Rock Hill Missionary Baptist Church. This sanctuary remains at the southwest corner of James Drive and State Road 426.

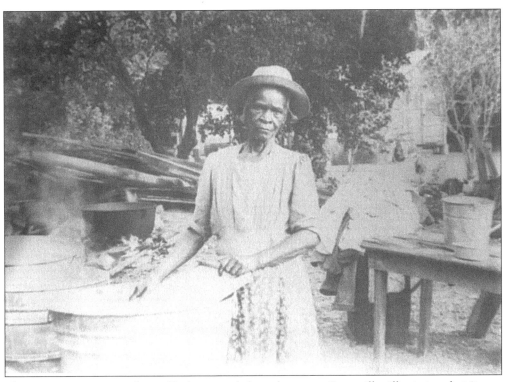

These two scenes, one from Chuluota and the other near Curryville, illustrate what it was like on wash days. Roxie, shown above at a wash tub, is cleaning clothes for the Jacobs family in Chuluota on Lake Mills Road. The photo below shows an unidentified mother and child at the laundry of one of the Curryville lumber camps.

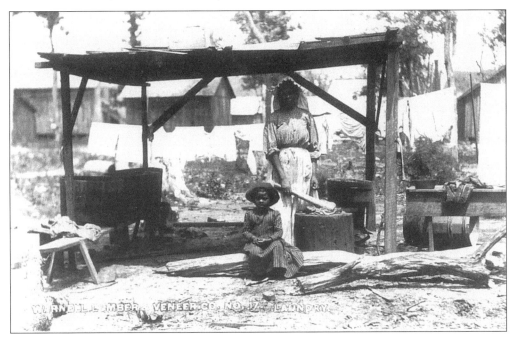

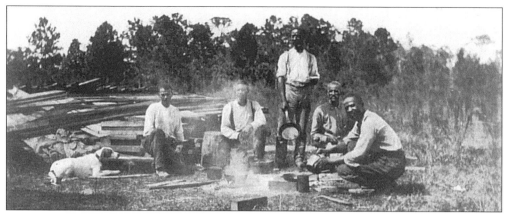

Timber and turpentine workers had to eat, even when they were far from home. Here, a crew gathers around an open fire for a mid-day meal in the pines and palmetto flat land at near Curryville. Timber workers in the 1920s discovered many old homesteads among the pine forest. Florida militia captain Albert G. Roberts of Alachua County married Anne E. Mizell, daughter of cattleman David Mizell, one of the early settlers of Winter Park. Roberts had journeyed though the east Seminole County area during the Seminole wars. In 1861, he selected the Curryville area for his homestead. He paid $5 to his wife's brother, Joshua Mizell, for the land, plus 100 head of cattle, 70 hogs, a seven-year-old bay mare, kitchen and household furniture, a horse cart, and farming tools. Roberts worked his farm and grove with two slaves and their three children.

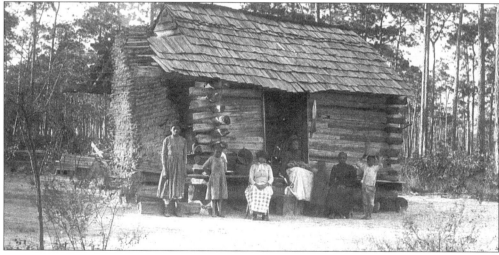

Wood-frame farmhouses like this one were once scattered throughout the Curryville community. Early settler Daniel Simmons lived next to property owned by D.W. Curry. Simmons' son, Tom Lane, was one of the many black workers who chipped box to collect pine sap. Curry's company built houses for workers throughout his 40 acres. A turpentine worker earned about 10¢ an hour in the 1920s and 1930s. Some of the workers pay was in cash, but most was in company tickets that served as money at the company's commissary. Maggie Branch, a black midwife at Curryville, delivered babies because the closest doctor was in Chuluota. After drawing the sap dried up the pines, Hilton Brown built the first of the sawmills at the Curry camp. This and other sawmills provided many jobs for area workers. By the 1840s Brown and other timber companies had stripped the area of pines.

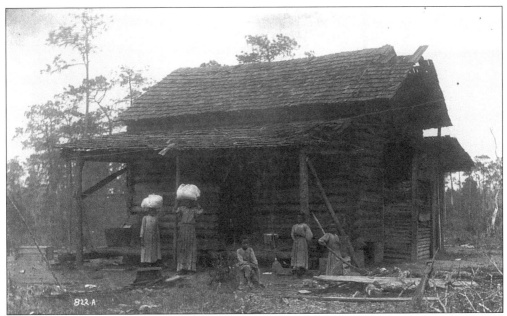

These scenes represent the housing in the Curryville and Snow Hill areas during the turpentine and lumbering days and well into the 1900s. They had as many cracks as they had boards. The houses served "not so much as to keep out the cold and the rain as to delay their passage," said Paul Wehr. The oldest houses had wooden shutters for windows "and gaping cracks in the floors, which proved beneficial only when sweeping dirt through them. When mosquitoes made their appearance, everyone slept under netting; but when they became too bothersome, the dwellers would ignite rags and place them under the floors. The smoke would rise through the cracks, driving away the mosquitoes as well as the inhabitants."

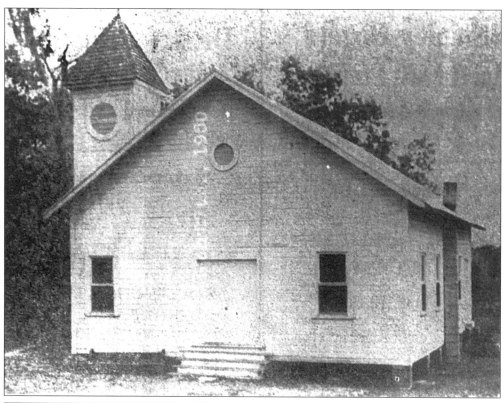

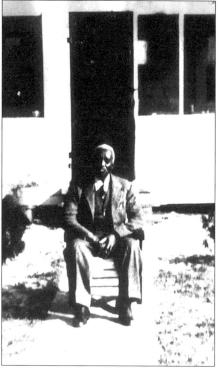

Henry Detreville, shown below outside his Snow Hill home, left Charleston, SC, with his wife, Sarah, when Florida farm work recruiter W.B. Smith told them, "Money is flourishing, you can pick it off the trees." They arrived in Chuluota, where Henry Detreville built a brush arbor for worship service and invited The Rev. Frank Miller of Oviedo to preach on Sundays. Detreville worked a 40-acre farm that he called Snow Hill, because the white sands of the Econ River looked like snow. He built a second brush arbor near the river, and on July 4, 1909, the congregation organized the Snowhill Missionary Baptist Church, shown above. The Rev. W. M. McMillian came from Geneva as the pastor. Detreville added another 40 acres to his farmland in 1921, including the land that he donated to the church. The Rev. E. J. Peacock was the pastor. Detreville died August 1, 1953. Sarah Bush, one of his nine children, lives on the family's land.

Eddie Banks' father built this wood-frame gas station and store in about 1939 to serve the Snow Hill community on the Econlockhatchee River and its creeks. The Banks family moved to the area in 1924 as one of many families drawn to the area to work at the nearby farms and citrus groves. Eddie Banks ran the store after his father, but most of the farming and the customers have moved on.

Lemuel Raymond Stallworth was born February 3, 1935, as the fifth child of Rev. and Mrs. John L. Stallworth Sr. Lemuel enjoyed drawing from an early age, but he could not afford paints and paper. Instead, he brushed away dirt where the ground was hard and used a stick to draw. An accomplished artist from an early age, he attended the Kolokee School, later renamed the Snow Hill School, where he was picked to paint the community's history. School Superintendent T.W. Lawson praised his work. After attending Oviedo Junior High, he enrolled at Crooms Academy and studied under J.N. Crooms. His family nicknamed him "Professor." Stallworth earned a four-year scholarship to Bethune-Cookman College in Daytona Beach. There, he worked during the summers, walking to save the bus fare. After college, he enlisted in the Army, later returning to Seminole County as a teacher at Midway Elementary School under Principal W.L. Hamilton. At the school, he met his future wife, another teacher, Sylvia Hammond.

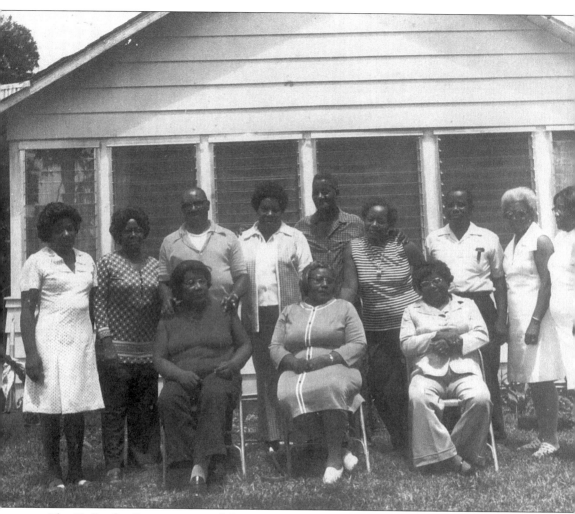

The Muller family were some of the early settlers at Geneva. Freddie M. Muller, sixth from the left in the top row, is the mother of musician Sherwood Mobley, former conductor of the Atlanta Symphony. Sherwood is now a timpanist with the Greenville, South Carolina Symphony Orchestra.

# *Three*
# THE ALTAMONTE-LONGWOOD AREA COMMUNITIES

*The Winwood/East Altamonte community's heritage is as old as South Seminole County's winter resort and fernery enterprises. Once part of Altamonte Springs, the residents of Winwood represented 40 percent of the city's population in the early 1920s. Altamonte's zoning laws in 1945 drew a line at Leonard Street and Longwood Avenue. White families lived to the west, and black families lived to the east. Winwood split off from the city in 1951 when its leading property owner, Condor Merritt, and 80 others won a lawsuit that claimed the city was collecting their taxes but not providing equal services. The court decision slicing off 80 acres of the northwest section for the city included the homes of the majority of the black residents of Altamonte.*

These members of the New Bethel A.M.E. Church choir, from left to right, are Dorothy Smith, Elizabeth Taylor, Cassie Jones and Christine Harris. They performed at a 1990 benefit to build a girls club. The church is in the heart of Winwood on Marker Street. In 1918, Winwood residents wanted a church closer than the ones in Longwood. The first sanctuary was about a block away from today's sanctuary. In 1928, a second church opened as the New Bethel A.M.E. Church.

Cedar Mason Neal was a Rosenwald teacher as well as a civic and community leader in Altamonte Springs.

Shown here is the entrance and sign at the Rosenwald Center, now used for students with special needs. The Rosenwald heritage represents as much to the families of East Altamonte and Longwood as Hopper and Crooms Academies meant to others. Rosenwald opened during segregation as one of many Southern schools founded through a Northern benefactor's foundation. It focused on basic academics, plus industrial arts and home economics. Julius Rosenwald provided the money to build modern, well-equipped schools in the rural South after World War I. Rosenwald, a clothing merchant in New York City and Chicago who bought 25 percent of Sears, Roebuck and Co. and became its president and later chair of the board, built in communities where the black and white residents agreed to contribute money or materials for the school, usually about one third of the costs. The Rosenwald Fund continued to match community spending in future years. The fund helped communities throughout the South raise $27 million to build 5,000 schools in 16 states, often establishing the models for construction standards for tax-supported public schools for white and black students as well as other community buildings.

Shown here are students looking over a book in the school's library in the mid-1970s and listening to teacher Connie Stone in one of the classrooms. The pictures were taken during the mid-1970s when Rosenwald was still a community school.

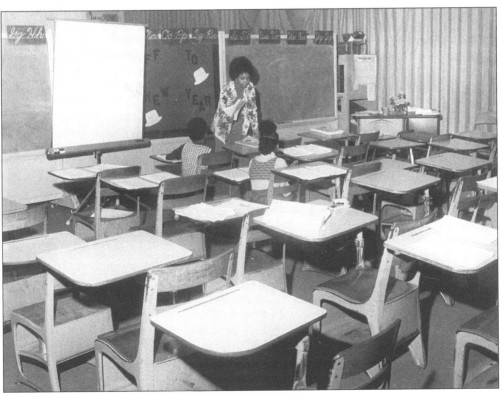

Winwood is the birthplace of Alcee Hastings, a Congressman from South Florida and a former federal judge. Hastings was the first black lawyer appointed to the federal bench in Florida.

Paul Snead married Condor Merritt's daughter Cora, and still lives with his family in Winwood. Snead taught at Rosenwald during his early career but retired as the district administrator for the state's family and social service agency when it was called the Department Health and Rehabilitative Services.

Horace Orr, seated, and The Rev. Amos Jones, born in Longwood, teamed up in the 1970s and early 1980s to start the Seminole Employment and Economic Development Corp., which used federal grants to encourage and invest in new industries to create jobs in Seminole County. Both attended the Rosenwald School and attempted to preserve its heritage in the community.

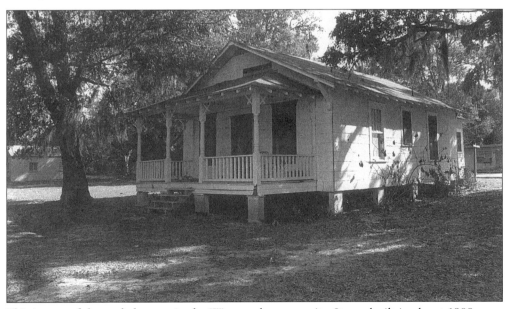

This is one of the early houses in the Winwood community. It was built in about 1900.

This orange grove, owned by Winwood's Condor Merritt, is now the site of the Red Bug Elementary School near Casselberry.

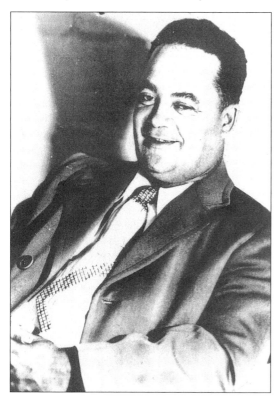

Alcee Hastings' uncle, Condor Merritt, paid for his education. Merritt, one of Central Florida's most powerful African-Americans, developed Winwood after World War II. He invested the money he made from picking fruit and legalized gambling just after World War II into nightclubs and country stores and a real estate empire in Orange and Seminole counties. Merritt died in 1973, but his family still owns rental property in the neighborhood.

Advertising posters like this one for James Brown's performance at Eatonville's Club Eaton popped up throughout Central Florida in the years when Condor Merritt made his club the area's leading nightclub for black artists. Merritt built the Club Eaton, now called Heroes, in 1950. Barred from white hotels, black entertainers liked Club Eaton because it had rooms upstairs where they could stay.

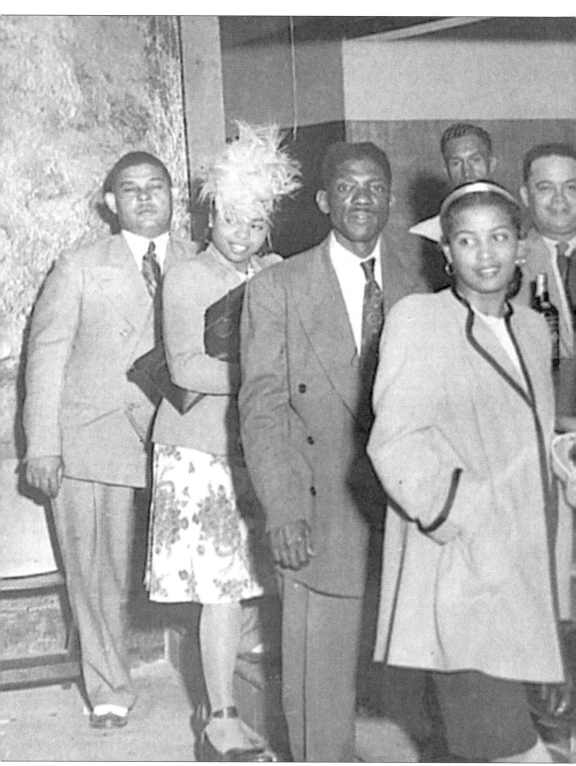
Patrons of Condor Merritt's Club Eaton knew they were required to dress for the occasion.

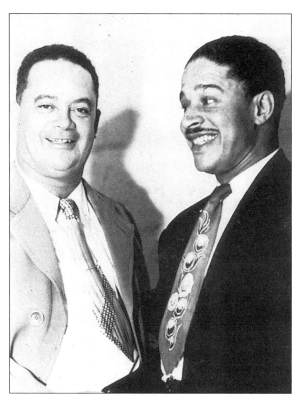

Condor Merritt shakes hands with Dr. Boykin of Orlando.

Condor Merritt entertains family and guests at his night club, Club Eaton.

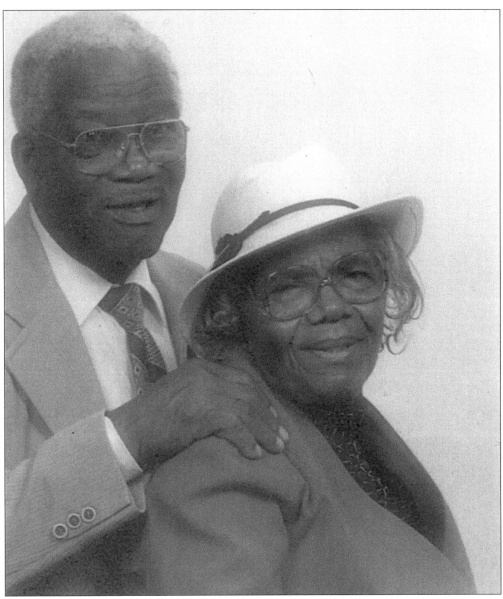

The Corinth Baptist Church was founded in 1883 by three black settlers on land donated by Longwood founder E.W. Henck near the railroad through downtown. Thomas Shepherd, one of the early settlers who later acquired major landholdings in Longwood, made the agreement with Henck for the church property. Many black laborers came to Longwood to work on the railroad, and many of those built their homes near the embankment. By the 1920s, white settlers had built homes around the Corinth Baptist Church, and they complained about the noise from night services, which stopped in 1924. Twenty years later The Rev. Oliver Glover, shown here with his wife, Maebelle Glover, was pastor when the church moved from its original site. The new site, at what today is State Road 434 across from the hospital complex, provided for the growing congregation and a return to night services. The name was changed to Mount Olive Missionary Baptist Church. The original site is within the city's historic district near city hall.

The author's father, The Rev. Charles J. Smith (left), was the second pastor at Corinth Baptist Church in Longwood. Smith met his future wife, Chaney Burnett (right), when they attended the Baptist Institute in Live Oak. They later settled in her family's hometown at Georgetown. During the week he worked at the general store that his wife's family owned at Third Street and Sanford Avenue. The church paid him $2 a week in 1894. He walked along the railroad tracks to get to Sunday services to save the train fare.

# EPILOGUE

The photographs and stories on the previous pages are the threads woven to record and preserve the history, legacy, culture, and folklore of Seminole County's vibrant older communities. They help display a pattern, a design that blends the customs, celebrations, and observations that highlight a variety of colors reflecting warmth and brilliance. Exploring the history behind the old buildings and sites reveals the rich and fascinating stories of the people who founded the first churches, schools, neighborhoods, and businesses. The differences among the people of the communities are not significant because out of these differences should come an understanding of how much people have in common. The early families came to these flat marshlands filled with hope and faith. They encountered severe hardships from every aspect of life. The black communities have contributed to the progress and success of their county. That struggle is not over, but with fortitude, we can become actively involved in economic development, the political process, and continued education. We must create a personal sense of security, knowing that dignity and a positive self-image belongs to each of us. The history of these communities is a tapestry that should inspire the next generations.

—Altermese Smith Bentley